Labyrinths & Mazes

Solvitur ambulando.
(It is solved by walking.)

—St. Augustine

Labyrinths & Mazes

A Journey through Art, Architecture, and Landscape

Francesca Tatarella

PRINCETON ARCHITECTURAL PRESS · NEW YORK

PUBLISHED BY
Princeton Architectural Press
A McEvoy Group company
37 East Seventh Street
New York, New York 10003

Visit our website at www.papress.com

PUBLISHED SIMULTANEOUSLY IN ITALY BY
22publishing srl
with the title *Labirinti: un percorso attraverso l'arte,
l'architettura e il paesaggio*
22publishing srl
via Morozzo della Rocca, 9
20123 Milan
www.22publishing.it

© 2016 22publishing, Milan
English edition: © 2016 Princeton Architectural Press
All rights reserved
Printed and bound in China
19 18 17 16 4 3 2 1 First edition

Translation: Natalie Danford

FOR PRINCETON ARCHITECTURAL PRESS
Project editor: Nicola Brower
Typesetting: Paul Wagner, Mia Johnson

Madisen Anderson, Janet Behning, Abby Bussel, Erin Cain, Tom Cho,
Barbara Darko, Benjamin English, Jenny Florence, Jan Cigliano Hartman,
Lia Hunt, Valerie Kamen, Simone Kaplan-Senchak, Stephanie Leke,
Diane Levinson, Jennifer Lippert, Kristy Maier, Sara McKay, Jaime Nelson Noven,
Esme Savage, Rob Shaeffer, Sara Stemen, Joseph Weston, and Janet Wong
—Kevin C. Lippert, publisher

Library of Congress Cataloging-in-Publication Data
Names: Tatarella, Francesca, 1975- author. | Danford, Natalie, translator.
Title: Labyrinths and mazes : a journey through art, architecture, and landscape /
 Francesca Tatarella.
Other titles: Labirinti. English
Description: First edition. | New York : Princeton Architectural Press, 2016.
 | "Published simultaneously in Italy by 22publishing srl with the title
 Labirinti: un percorso attraverso l'arte, l'architettura e il paesaggio."
 | Includes bibliographical references and index.
Identifiers: LCCN 2016007714 | ISBN 9781616895129 (alk. paper)
Subjects: LCSH: Labyrinths in art. | Symbolism in architecture. | Maze gardens.
Classification: LCC N8219.L22 T3813 2016 | DDC 712—dc23
LC record available at http://lccn.loc.gov/2016007714

Contents

Preface

A labyrinth or maze is by definition mysterious and enchanting. For a long time I have been fascinated with the history of these structures and their various forms. When I first had the idea of writing this book, I began by seeking out publications, sifting through printed materials in libraries and bookstores and surfing the Web to find answers to some basic questions: What exactly is a labyrinth? What are its characteristics? How is it made and what is used to build it? How have its appearance and form as well as its meaning and function changed over the centuries?

It soon became apparent that there were numerous labyrinths and mazes suitable for inclusion in this book. After careful evaluation I chose a selection based both on significance and aesthetic qualities; unfortunately, I had to omit some interesting examples because they had not been well-preserved, there were no high-quality photographs of them available, or—while based on interesting concepts—they simply did not achieve good formal results.

Everything seemed to be under control, and I was working at a steady pace, always looking out for new information that might feed into my theme. I was walking my path with purpose, convinced that I was headed in the right direction and secure in the belief that I would reach my goal and complete my task. But, just as when you are in a maze and think you have figured it out, I stumbled onto a fork in the road. Which direction should I head? Which lead should I investigate further? Often during my work for this book my decisions led me to discover new relevant information—but just as often the paths I took turned out to be dead ends. In other words, researching this book was the intellectual version of making my way through a maze or labyrinth. Surprises awaited me around every corner, and crafting a single unified definition of a labyrinth or maze that could account for all of its many meanings ultimately proved impossible.

As in the physical world, in research you need patience to follow the entire path to its logical conclusion at the center and then to turn around and find your way back to the exit. In order to write this book, I first had to collect information on the evolution of form that this mystical kind of architecture has undergone over time, as well as on the significance assigned to its incarnations at various times, and how its design, construction, and use have changed. This was a massive undertaking that involved codifying types and meanings and navigating numerous differing visions,

cultural crossover, formal languages, religious beliefs, philosophical concepts, and visual solutions, as well as the more concrete issues of the methods and materials employed. It is easy to get lost in such an examination of labyrinths and mazes, just as it is easy to get lost in an actual labyrinth. After the initial excitement of starting the project had subsided, the main question I was left with was how these complex and fascinating structures can be interpreted. Is there a unifying thread? And if so, what is it?

The many different existing types, plans, forms, and meanings of labyrinths and mazes were disorienting and made it difficult to establish a single set of ironclad rules that would account for all of them and help look at them as a whole.

So what was to be done?

When you can go neither backward nor forward, neither right nor left, all you can do is stay where you are and think. Doing just that led me to a single certainty: at their heart all mazes and labyrinths deal with fundamental questions and concepts of human existence, much more so than other works of architecture or art, or simple paths, do. That is why people built them in the past and still build them today and share them with their communities. These concepts have shared roots, though they have been translated into wildly different forms.

I came to the conclusion that the common denominator in all mazes and labyrinths is that they play off of our relationship with mystery and the unknown—anything that cannot be touched, tasted, measured, weighed, counted, or defined. Labyrinths help us draw closer to mystery and stave off the fear that the unknown creates in us. They deal with questions such as, Should I even start a journey if I don't know where it will take me? Will I get lost if I head down an unknown path? And if I do get lost, will I be able to find my way back to the main road? Labyrinths both confront me with my fears and help me overcome them. Traveling through a labyrinth or maze takes away its power. If I manage to overcome my fear and venture into the unknown, I will find my way to the exit and prove to myself and everyone else how brave I am.

The mazes and labyrinths in this book reflect that reasoning, whether their makers are conscious of it or not. Some of the examples featured in this volume are ancient and traditional, while others are the more recent work of contemporary artists and architects who reinterpret these age-old

symbols employing new concepts and forms. This book is by no means a history of labyrinths. Rather, it uses historical examples as a jumping-off point to look at contemporary art and architecture.

Although works of literature and cinema as well as neuroscience frequently make interesting use of labyrinths in a figurative way—as narrative structures, allegories, metaphors, and mental constructions—this book focuses only on physical examples. Each maze and labyrinth included here has an inside and an outside. Some have a single path, while others employ multiple paths that intersect. Each has a center, an entrance and an exit, and walls—whether made of stone, hedges, glass, or ice. Ultimately, a labyrinth provides a physical human experience. The mazes and labyrinths in this book are places where it rains or where the sun shines, where there is wind, where it is warm or cold, where there is light or darkness. You experience them with your body and not just your mind.

I hope this book will serve as a kind of map that readers can use to orient themselves within this intriguing and complex subject. While I have just emerged from this maze of information after following my very own personal path with passion, effort, and enthusiasm, I invite you to make your own journey through it. Good luck!

—Francesca Tatarella

Introduction

As we have learned above, giving a single, precise definition of labyrinths and mazes is not very easy. Are they merely architectural works? Are they sacred or religious structures used for praying, like temples? Or are they small follies built to entertain and provide pleasure? The one thing we can say for sure is that a labyrinth or maze is a structure with one or several paths. More specifically, while in most types of architecture a path is simply an element that leads to other places, in a maze or labyrinth the path *is* the architecture. In other words, the path is not just a means of moving from one space to another but a destination in and of itself. To move through a maze is to travel its path. "*Solvitur ambulando*" ("It is solved by walking"), as the African bishop and philosopher St. Augustine is believed to have said: In order to get to know a maze, you must follow it, enter it, get lost in it, and make your way out of it again.

The classical labyrinth symbol consists of a single path that leads from the labyrinth's exterior to its center, winding around itself in a round, square, or rectangular shape. This type of labyrinth holds no surprises, red herrings, or dead ends. Early examples of labyrinthine patterns—carved into rock surfaces or painted on walls or pottery and in some cases dating back to prehistoric times—can be found mainly in Europe but also in North Africa, the Indian sub-continent and Indonesia, the American Southwest, and South America. Historians believe that the labyrinth symbol initially spread throughout Europe and then to other continents, where native cultures developed the basic design and shaped it to their own characteristics and beliefs.

This type of classical labyrinth is also referred to as "Cretan," based on the Greek myth of King Minos, Theseus, Ariadne, and the Minotaur. In its more primitive form, it has just three circuits leading to the center, but often there are seven. Today many physical examples of classical labyrinth designs still survive in Scandinavia, especially along the coastline of the North Sea. Their paths were outlined using rocks and boulders. Some date back to the Viking Age, but many were built later. There are also examples in England, where they were dug into soft soil and green fields and are known as turf labyrinths or turf mazes; their circular paths hold no mystery. You can clearly see how to get in and back out. They do not induce disorientation, and they were not meant to. Rather, these unicursal (single-path) structures were traveled in order to perform ancient rituals—a prayer to the gods that those far away will return safe and sound, or that an heir will be born. They can be followed an

infinite number of times. Entering and exiting such a labyrinth is like repeating a mantra. The repetition is the point. These labyrinths are thus not just structures but serve as choreographies for rites and pagan prayers. Indeed, in many documents dealing with Etruscan culture in central Italy, the labyrinth is referred to as *truia*, which literally means "dance surface" or "dance arena."

During the Roman Empire, labyrinth patterns were often used in mosaic floors in the villas of affluent citizens or important public buildings. The so-called Roman labyrinths are variations of the basic Cretan layout, but they often take a square or rectangular shape, and there are numerous variations, with more or less circuits.

In medieval times, the classical Cretan or Greek labyrinth was used in a Christian religious context and can be found in the decoration of church walls and floors. These designs often take polygonal shapes, such as octagons, and have eleven concentric circuits leading to the center. In this context, the labyrinth becomes a metaphor for the world of sin, and following its path symbolizes man's ascent from sin to redemption.

During the Renaissance, a very different type of labyrinth evolved. While the Middle Ages had been a time when the religious influence on life was of great consequence and defense was all-important, the Renaissance was a period when man and his free will and freedom of choice took center stage in cultural and philosophical discussions; as a result, entertainment purely for its own sake came into favor. The art of garden design developed alongside the craft of architecture, as both were needed to transform the medieval fortresses and other defensive buildings into more lighthearted country homes intended for leisure time. One way to achieve this was to create a maze or labyrinth in the garden. These Renaissance mazes—lighter in spirit than their predecessors—generally are multicursal; they have multiple paths that encourage users to meander along different routes, representing man's freedom of choice and freedom from religious duty and symbolizing the era's open attitude toward pleasure, which was no longer considered a sin. Mazes were designed as sophisticated adult games; aristocrats delighted in playing them and demanded them for their gardens.

Besides the introduction of multiple pathways and dead ends during this period, the Renaissance saw other important developments in maze design, including new methods of creating them.

Boxwood and hornbeam hedges came into fashion, as they could be grown into walls high enough to hide the horizon, increasing the sense of stepping into another world. Another innovation was the use of raised portions both along the paths and—more frequently—at the centers of labyrinths. These incorporated pavilions and small towers that visitors could climb to see the maze in its entirety and try to spot the way out. On a more practical level, groundskeepers could check that no one remained trapped inside the maze at the end of the day.

The two types of labyrinths discussed above are also the basic designs after which more recent labyrinth and maze structures are modeled. Today artists and architects create labyrinths out of many different materials and in a wide range of forms; the results express an equally wide variety of symbolism. Many contemporary artists look at mazes and labyrinths as spiritual structures. Some hark back to the tradition of mazes carved into the earth, while others dream up complex structures that recall the myth of the Knossos labyrinth and its Minotaur. These types of labyrinths are purposely confusing, so that anyone who enters and then manages to find a way out becomes a victor—someone who has faced danger and conquered it.

Indeed, the modern labyrinth is often posited as a kind of prison. Unlike a Renaissance maze, which puts emphasis on pleasure, it instills a sense of confusion or even coercion generated by paths that demand to be followed. These mazes are often built of hard materials, such as stone or even the type of metal fencing typically associated with houses of detention, representing a feeling of disorientation resulting from a lack of clear moral, social, and cultural references. The labyrinth or maze in this context is not only a symbol of man becoming a victim of his own evolution, but it also serves as a device that makes people realize—through the physical act of following a path in a constricting structure—that they might be subject to certain behaviors or ways of thinking that limit their freedom.

Labyrinths & Mazes presents both historical and present-day examples, with the intention of showing a wide variety of meanings and designs. Starting with some early examples of classical labyrinths (as seen in medieval churches and a seventeenth-century turf maze), the book goes on to show how contemporary artists use this basic pattern in their work. This section is then followed by a variety of hedge mazes inspired by the Renaissance layout with multiple paths and dead ends,

and the last part of the book features examples that explore other materials, including glass, metal, wood, stone, and even snow and salt. For each project, some basic parameters, including location, year of creation, designer, material, and size (where available), are given as well as a brief description.

Both historical and modern labyrinths and mazes rely heavily upon the relationship between the signifier—the form and visual language of construction or design—and the signified—the experience of the labyrinth. The result is an interplay between form and substance, signifier and signified, theory and practice, thought and action. Whether they are made out of earth, stone, wood, or ice; whether they have high walls or are simply traced on the ground; or whether they have a single pathway or multiple routes, labyrinths and mazes are unusual works of architecture that attempt to represent man's complex journey through the world.

The simple act of following a single path through a classical labyrinth was meant to exorcise fear of an unhappy fate; the Renaissance mazes with their cul-de-sacs and multiple paths were more of a test to be overcome, much like the difficulties that life lays in each of our paths. The sense of imprisonment and suffocation that assails anyone who ventures into a contemporary maze built of tall and solid walls echoes the dark periods in life that can seem to lock us in a cage and deprive us of physical freedom or freedom of expression. In order to push through, we may rely on prayer, omens, or hope to find the courage to face life's adversity, conquer it, and, finally, achieve a state of happiness and peace.

In difficult times, we are greatly disoriented by pain, death, or fear of the unknown. Since ancient times, humans have felt it necessary to give shape to this often paralyzing fear—a shape that allows us to contain our terror and desperation in a defined, limited space and to overcome it by moving through it. The labyrinth, then, becomes a useful tool that helps us deal with the dark side, because, just as St. Augustine said, only through action, through walking, can we identify the solutions to our problems and emerge victorious over the obstacles in our paths.

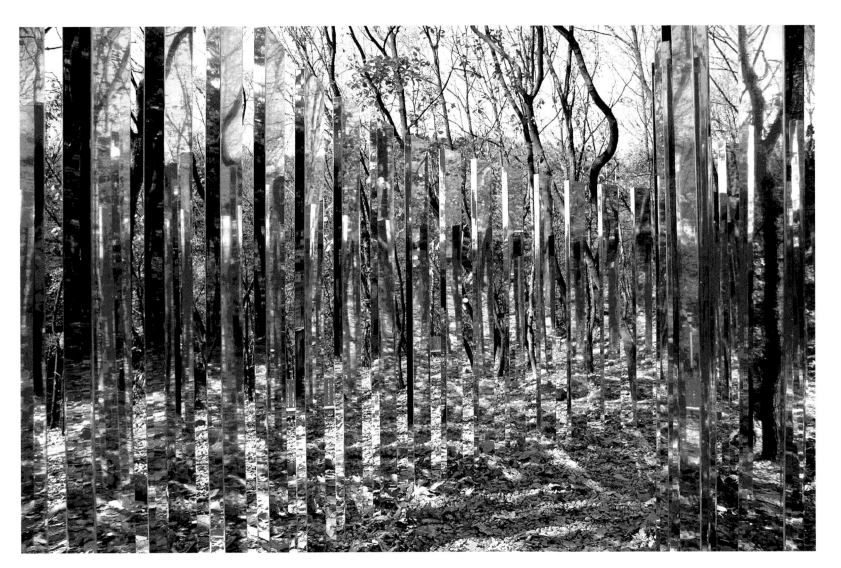

Labyrinths & Mazes

Chartres Cathedral Labyrinth

- **Designer:** unknown
- **Location:** Chartres Cathedral, Chartres, France, early thirteenth century
- **Size:** 40.3 x 41.3 feet (12.3 x 12.6 meters)
- **Material:** stone

The labyrinth laid into the floor of Chartres Cathedral is typical of Christian Medieval tradition. Its pattern is based on the classical Cretan labyrinth but consists of eleven rather than seven concentric circles, reflecting Christian number symbolism, in which eleven is considered a number of sin, as it exceeds the number of commandments.

Created in the early thirteenth century, the Chartres labyrinth has a slightly elliptical layout and fills the width of the church's central nave. Various meanings have been attributed to this and similar pavement labyrinths. Some scholars believe that it represents man's path from his life on earth to God, with the center of the labyrinth representing heavenly Jerusalem. Walking the labyrinth would then symbolize traveling through life, with that journey culminating in the arrival in Heaven and eternal life. Others claim that its path stands for man's interior journey to reach God through prayer, and that the apex of that journey is represented by the six-petal rose at the labyrinth's center—an emblem of the Lord's Prayer.

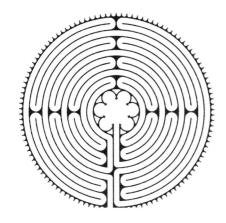

The labyrinth is traveled from the outside to the center and then back out by retracing one's steps. Pilgrims are invited to follow its path, which leads toward the cathedral's choir in the east, where divine light radiates through large windows. Altogether the path makes twenty-eight loops and terminates in a short straight path to the center rosette.

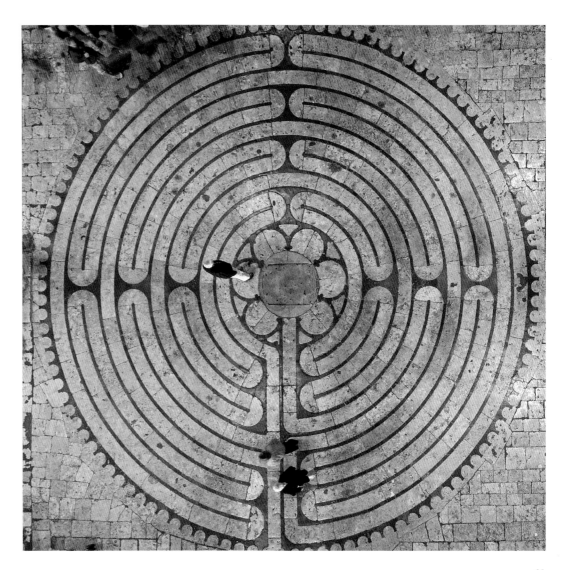

Amiens Cathedral Labyrinth

- **Designer:** Renaud de Cormont
- **Location:** Amiens, France, 1288 (reproduced in the nineteenth century)
- **Size:** octagon with a perimeter of 136.5 feet (41.6 meters)
- **Material:** stone

Amiens Cathedral was modeled after Chartres Cathedral, and like the latter it has an immense pavement labyrinth positioned in the central nave, though its shape is octagonal rather than elliptical. The labyrinth is just one among several black-and-white geometric patterns decorating the cathedral's floors. Its walkway is formed by black stone tiles, with white ones functioning as walls. The black stone at the center of the labyrinth bears an inscription with the names of the cathedral's three architects (Robert de Luzarches and Thomas and Renaud de Cormont).

After the labyrinth was heavily damaged during the French Revolution, it was removed. What we see today is a faithful reproduction created in the nineteenth century. It is usually kept free of chairs to allow pilgrims and other visitors to travel its path.

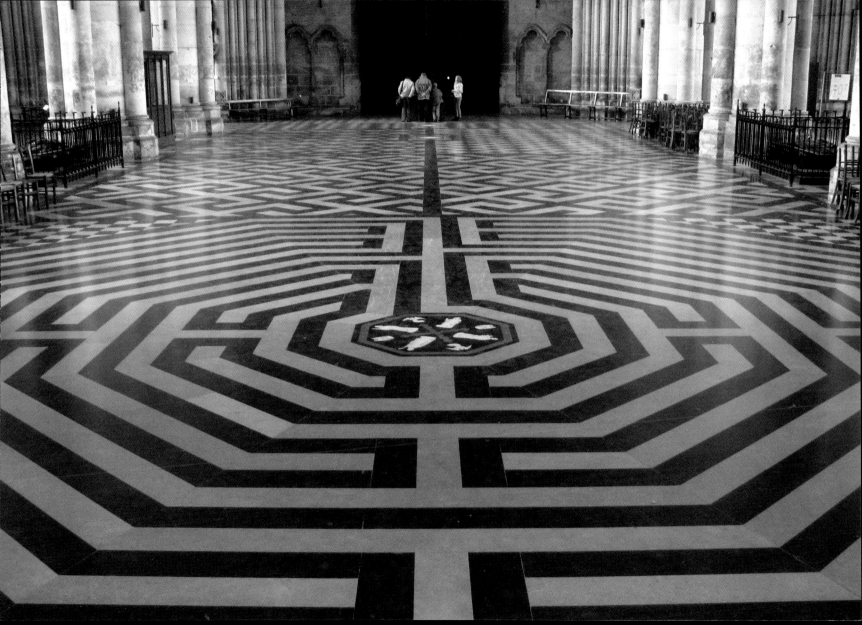

Saffron Walden Maze

- **Designer:** unknown
- **Location:** Saffron Walden, Essex, UK, 1699 (re-cut in 1911 and underlaid with bricks)
- **Size:** 88.6 feet (27 meters) in diameter
- **Material:** turf

The Saffron Walden maze is a turf maze dug directly into the soil, a type of labyrinth commonly found in Anglo-Saxon and other northern European countries. Many of these labyrinths are located in the United Kingdom, Denmark, and Sweden; some examples are also found in Poland and the Czech Republic.

These are some of the oldest extant labyrinths. The technique used to create them was simple: the path was cut into the earth, leaving a small raised border along the sides. Generally, these are unicursal designs with only one route to follow from the exterior to the center, and they typically range from 29 feet (9 meters) to 60 feet (18 meters) in diameter.

The Saffron Walden maze is widely believed to have been built as a simple unicursal maze, whose design was later modified with the addition of four small hills at the corners that make it more dynamic and interesting. Seventeen circuits form the walkable portion of the design and are decorated with bricks. The path leads to all four corners of the maze before

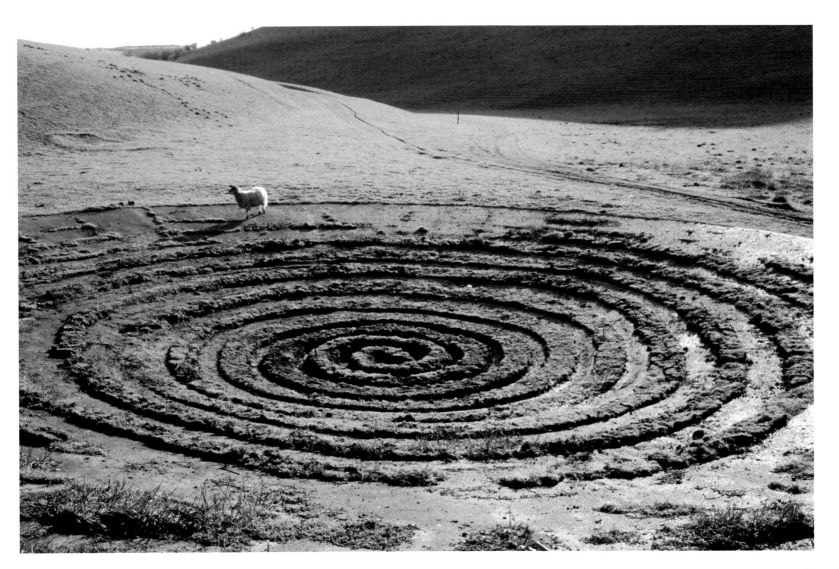

Snow Vortex

- **Designer:** Chris Drury
- **Location:** Firle Downs, Sussex, UK, 1999
- **Material:** snow

This ephemeral labyrinth was created on a frozen, snow-covered dew pond. These artificial ponds are used to provide water for livestock, and the technique for building them with layers of puddled chalk on straw dates back as far as the Neolithic period. For *Snow Vortex*, Drury first designed a labyrinth pattern and then traced it on the ground by rolling five snowballs.

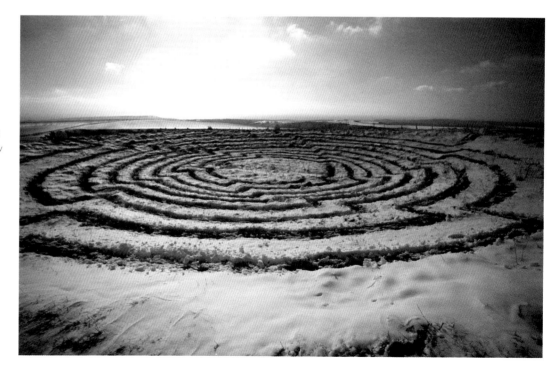

Turning

- **Designer:** Chris Drury
- **Location:** Sainsbury Centre for the Visual Arts, University of East Anglia, Norwich, UK, 2005
- **Size:** 147.5 feet (45 meters) in diameter
- **Material:** grass, pine logs, and pine branches

This labyrinth was created for an exhibition at the University of East Anglia. Working in an overgrown field, the artist mowed the path of the labyrinth into the grass. At its center was a vortex of pine logs and branches, arranged in a spiral pattern.

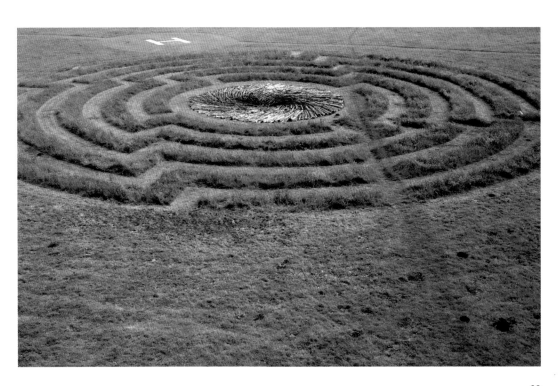

Sod Maze

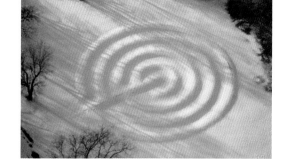
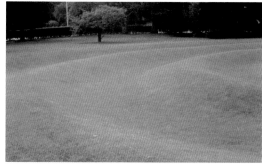

- **Designer:** Richard Fleischner
- **Location:** Chateau-sur-Mer, Newport, Rhode Island, USA, 1974
- **Size:** 142 feet (43 meters) in diameter
- **Material:** soil

Environmental artist Richard Fleischner created *Sod Maze* as part of the *Monumenta* outdoor sculpture exhibition held in Newport, Rhode Island, in 1974. The work was designed to fit the natural shape of the land. It merges so seamlessly into its surroundings that it is almost imperceptible—its raised banks are never more than 18 inches (45 centimeters) above the ground, and the whole maze, both the path and its raised borders, is covered in grass. Perception changes as the light and seasons change: in winter, when the maze is covered in snow, it becomes more visible.

This is a quiet piece of art that inspires contemplation. Once visitors become aware of it, they pass amid its waves and take in the surrounding countryside. Arriving in the center, one feels perfectly centered and oriented in the landscape.

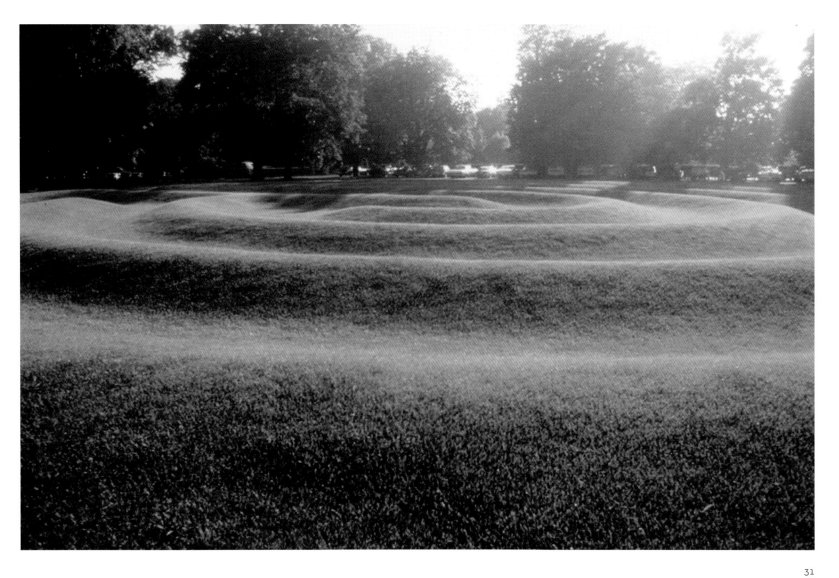

Fingermaze

- **Designer:** Chris Drury
- **Location:** Hove Park, Brighton, UK, 2006
- **Size:** 98.4 x 137.8 feet (30 x 42 meters)
- **Material:** York stone in lime mortar set into turf

This artwork by Chris Drury combines a classic labyrinth design of the Cretan tradition with the distinctive and unique pattern of a human fingerprint. Visitors following the trail to the center of the maze experience the exterior landscape with all its physical elements—cold, heat, wind, etc.—while simultaneously taking a meditative journey to their interior worlds.

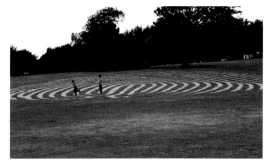
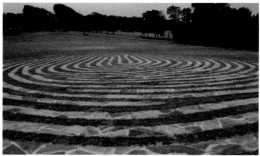

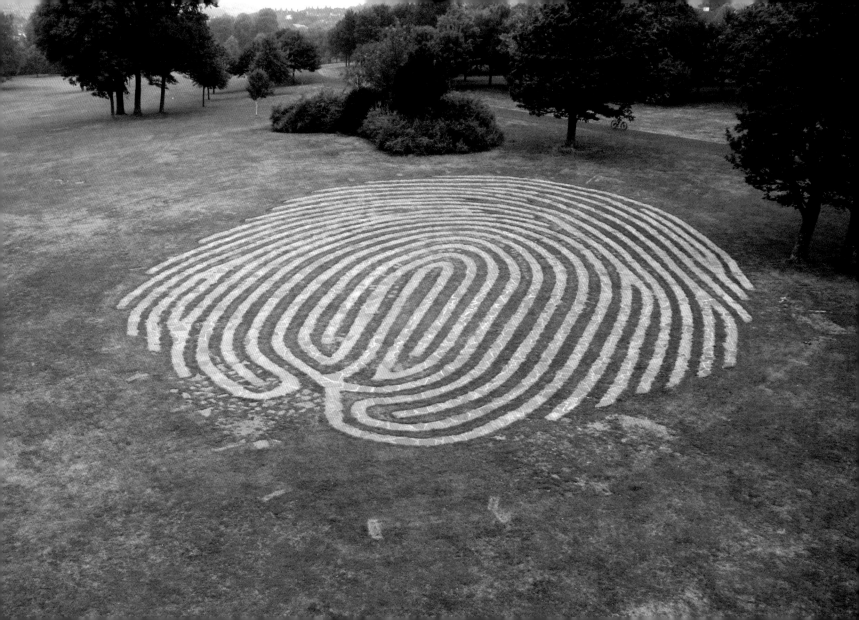

Mallum Labyrinth

- **Designer:** Jim Buchanan
- **Location:** Eibergen, Netherlands, 2002
- **Size:** 114.8 x 114.8 feet (35 x 35 meters)
- **Material:** soil and found bricks

The Rouffaer-van Heek Foundation invited Scottish artist Jim Buchanan to create a work on the site of the former Mallum Castle, of which only the moat remained, to serve as a reminder of the site's cultural and historic importance. Residents of the area used to export raw amber to as far away as the Mediterranean coast so that it could be processed and made into jewelry and other precious objects. With his labyrinth—a symbol of travel—Buchanan aimed to reference the trade routes that once connected Northern Europe and Scandinavia to the southern Mediterranean.

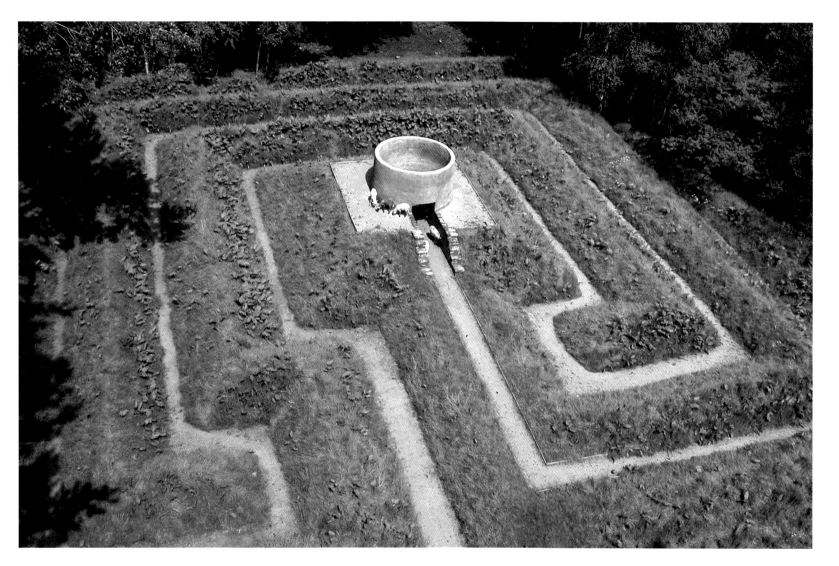

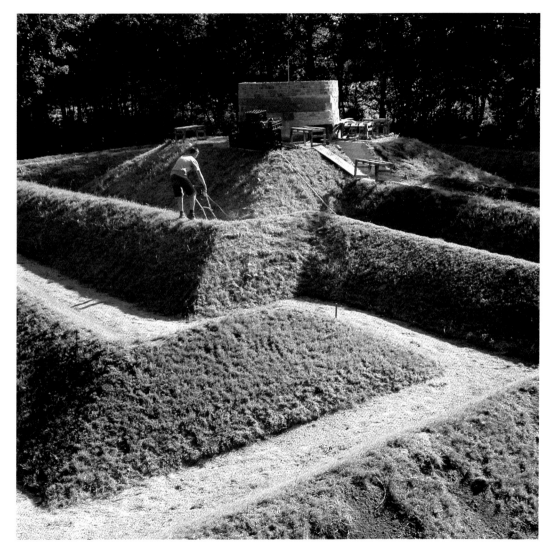

The artist, who was inspired by the image of an ancient square labyrinth on a Cretan coin dating to 500 BCE, visited the legendary Knossos palace on the island of Crete to get in closer touch with the source of his inspiration: the myth of Theseus and the Minotaur.

The labyrinth was made with soil collected from archeological digs in the area. The square layout consists of three circuits, and the path terminates at a small circular tower made with materials found on site, mostly bricks from the ruins of the ancient castle.

Though this rotunda was conceived as a shelter for visitors and contains a small bench, it has no roof and is open to the sky, which the artist considered an element of the surrounding landscape. From its raised vantage point, the tower offers a view of the labyrinth from above; from inside the labyrinth, however, visitors need to remain alert, as the grass-covered earth walls are tall and obscure their vision.

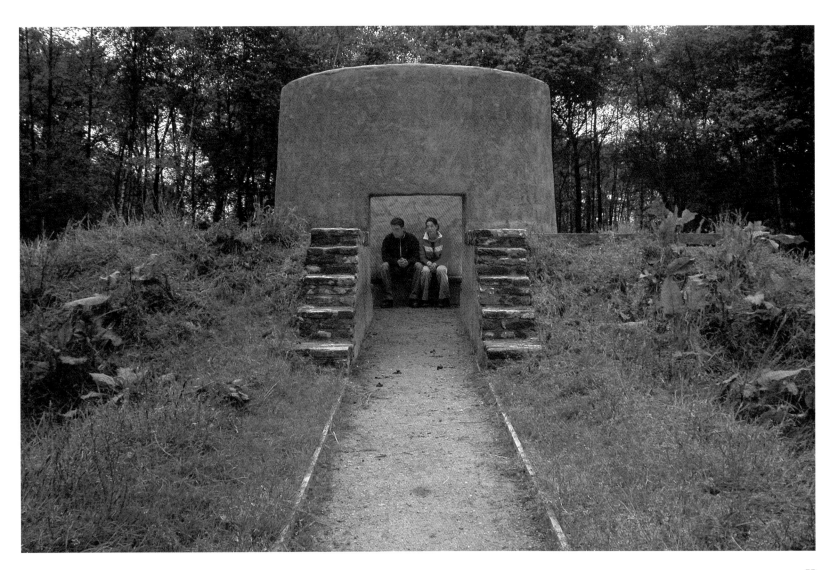

Central Garden Azalea Maze

- **Designer:** Robert Irwin
- **Location:** Central Garden of the Getty Center, Los Angeles, California, USA, 1997
- **Material:** azalea plants on a concrete support structure

Installation artist Robert Irwin designed the Central Garden at the Getty Center in Los Angeles as a single unit and conceived of it as an art garden suitable to house the work of various artists. Among the many water features of the garden is a pool that is planted with a maze of azaleas. Indeed, water in the garden is key not only as decoration but also from a functional viewpoint: it nourishes a wide variety of plants, including the azaleas that compose the maze and explode into bloom in spring, turning a deep pink and red color.

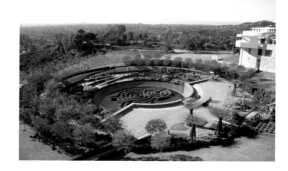

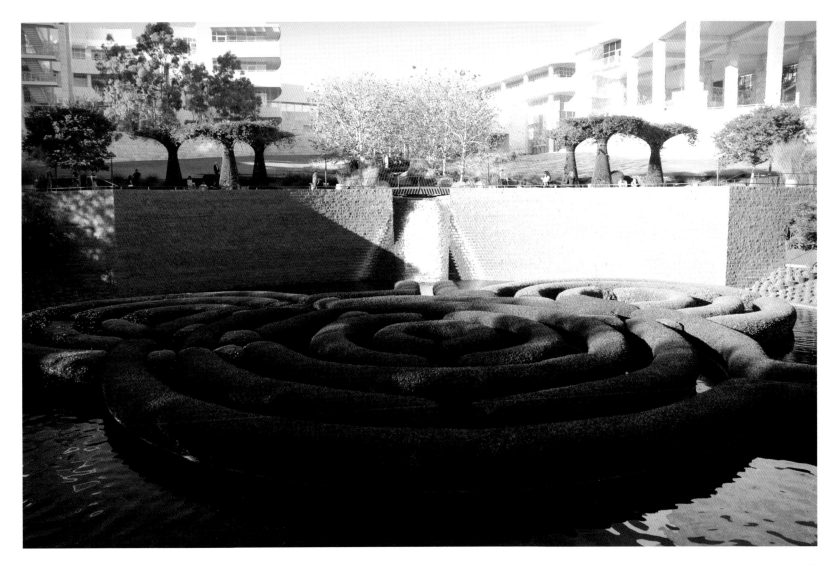

Masone Labyrinth

- **Designers:** Franco Maria Ricci, with architects Pier Carlo Bontempi (buildings) and Davide Dutto (landscape design)
- **Location:** Fontanellato, Parma, Italy, 2015
- **Size:** 1.85 miles (3 kilometers) of paths winding through 17 acres of land
- **Material:** 200,000 bamboo plants

In 1977 the Italian publisher, designer, and art collector Franco Maria Ricci promised Argentine writer Jorge Luis Borges, who had long been fascinated with the labyrinth as a symbol, that he would design and build a great labyrinth, the largest in Europe. The complex, which was completed in 2015, includes exhibition spaces for Ricci's collection of artworks from the sixteenth to the twentieth centuries and a library with works on typography and graphic design by the famed printer Giambattista Bodoni as well as the complete works of publisher Alberto Tallone. Also on display are books published by Ricci's own publishing house.

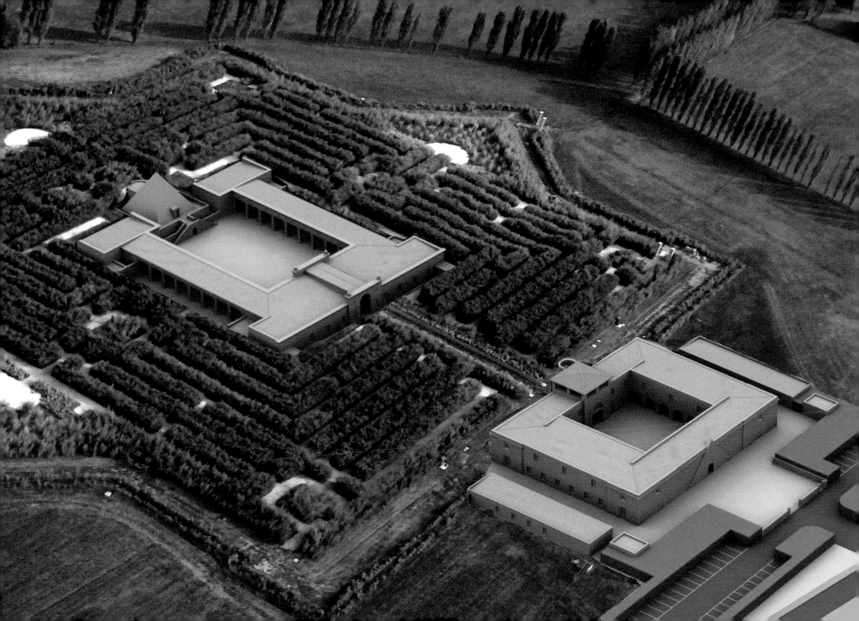

The labyrinth's main pattern is based on the classic Roman labyrinth with right angles. It is divided into quarters, or rather, it consists of four labyrinths that are connected to each other. The design departs from its classic model, however, with the inclusion of forks in the path and dead ends, which were not part of classic unicursal Roman labyrinths. The perimeter is star-shaped, a design that appeared for the first time in Filarete's *Treatise on Architecture* (ca. 1464) and then was used by Vespasiano Gonzaga in the town plan of Sabbioneta, with its star-shaped city walls, and by the Republic of Venice in Palmanova in the Friuli region.

At the labyrinth's center is a 21,527-square-foot (2,000-square-meter) plaza that serves as a venue for concerts, festivals, and temporary exhibitions, which complement the permanent collections on display inside the museum complex. What is special about the Masone Labyrinth is the way it marries the idea of the labyrinth with an architectural project to create a new space suited to various activities. Among the buildings of the labyrinth is a pyramid-shaped chapel that echoes the ancient ties between labyrinths and Christianity and specifically Catholicism.

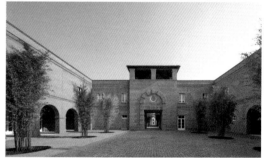

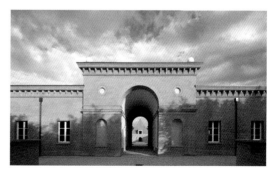

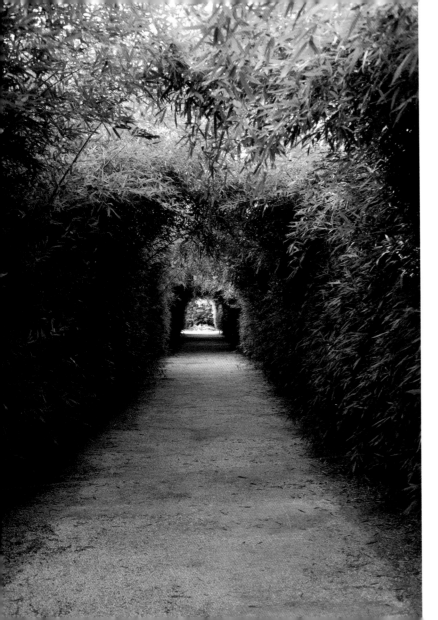

The labyrinth's paths are bordered by bamboo walls, which are up to 16.5 feet (5 meters) tall. Some of the plants are neatly trimmed, in order to delineate the walkways crisply; in other areas, they have been allowed to grow freely, creating paths that are almost completely covered—veritable plant tunnels. The choice of bamboo influences the shape and texture of the hedges in an interesting way. At first sight, the surface looks dense and compact, but the thin stalks of bamboo allow light to filter through, so that people walking through the labyrinth are afforded glimpses here and there of what lies beyond the walls.

Ricci used bamboo in the labyrinth not only for the hedges but also for the parquet floors inside the buildings, lending consistency to the project. The design and construction of the Masone Labyrinth involved planting a total of 200,000 bamboo plants throughout the park. A full twenty different species were used, including dwarf bamboo and giant bamboo. Bamboo is worthy of this attention—it thrives in all kinds of conditions, does not shed its leaves in winter, and serves as an efficient air purifier with its carbon dioxide absorption.

Horta Labyrinth

- **Designers:** Domenico Bagutti and Joseph Delvalet
- **Location:** Parc del Laberint d'Horta, Barcelona, Spain, 1794
- **Size:** 147.7 x 164 feet (45 x 50 meters)
- **Material:** cypress hedges

The Parc del Laberint d'Horta was the brainchild of a Catalan nobleman, who in the late eighteenth century decided to renovate the large ancient estate of his family, commissioning Italian architect Domenico Bagutti and French gardener Joseph Delvalet to design the garden's layout, buildings, plantings, and decoration. In the mid-nineteenth century, the park was expanded with a romantic bent. In 1969 the family agreed to sell the property to the city of Barcelona, which opened it to the public and renovated it in 1993. The labyrinth is the garden's most famous feature, but its many walkways, statues, and especially its lush vegetation, including examples of topiary art—typical of gardens from the sixteenth to the eighteenth centuries—all combine to make this park truly worth a visit.

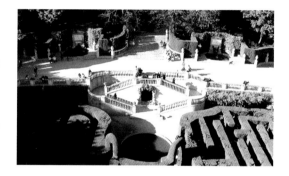

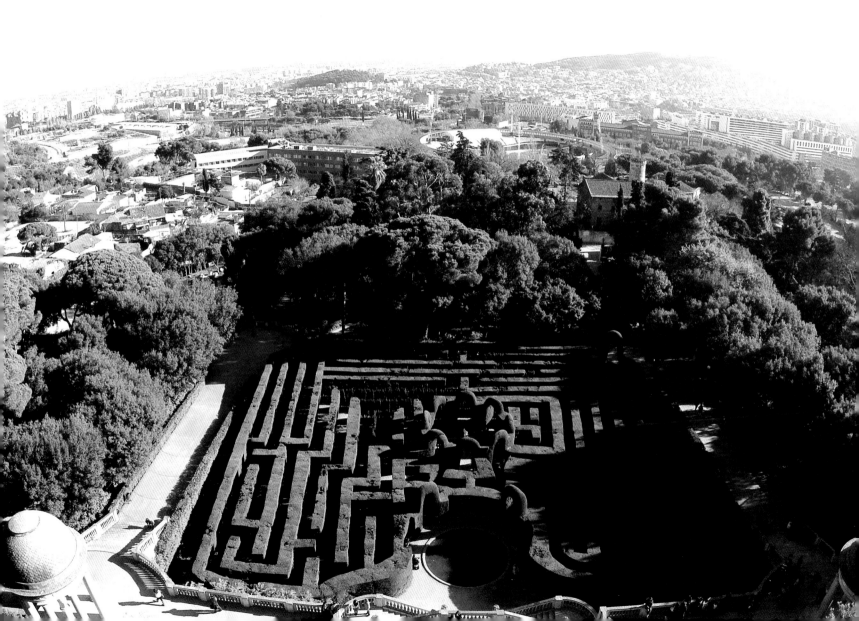

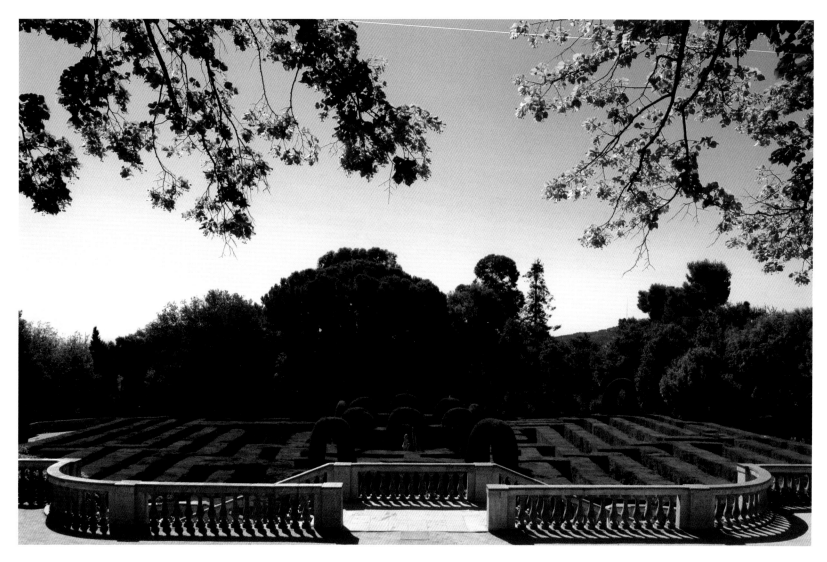

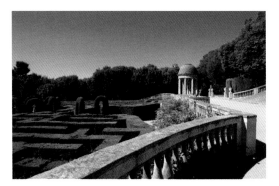

The labyrinth within the park is a Renaissance-style maze with a complex series of paths, cul-de-sacs, and detours. Getting to the center of the maze is relatively easy, but finding your way out is a challenge. The maze's hedges, which are up to 10 feet (3 meters) high, cut off the view of the surroundings, disorienting those within. At the center of the maze is a statue of the Greek god Eros.

The maze is located in the middle of the park. On higher ground above it is a marvelous neoclassical building that provides a view of the maze below and is the best vantage point for studying the intricate series of paths that wind through it.

The center of the maze is highlighted by hedges that have been trimmed into arches even taller than the other hedge walls. Together they form a circle of arches that can be seen from various points along the winding paths, so that visitors traveling the maze can keep their eyes on their destination.

The statues located at the four corners of the maze include a statue of Ariadne, an important figure in the Greek myth of Theseus and the Minotaur.

Borges Labyrinth

- **Designer:** Randoll Coate
- **Location:** San Giorgio Maggiore Island, Venice, Italy, 2011
- **Material:** 3,200 hornbeam hedges

On June 14, 2011, the Fundación Internacional Jorge Luis Borges and the Fondazione Giorgio Cini unveiled a maze garden in Venice—one of celebrated writer Jorge Luis Borges's favorite places—that British maze designer Randoll Coate had designed in the writer's honor and donated to the foundation named after him. The maze, which is located behind the Palladio Cloister and the Cloister of the Cypresses, serves as a kind of third cloister, being approximately the same size as the other two. The purpose of this project was to craft a garden that pays homage to the writer—a space with great spiritual import that draws the visiting public into the author's world. Its design was inspired by the Borges story "The Garden of Forking Paths," first published in 1941. Seen from above, the hedges that make up the maze spell out the writer's last name.

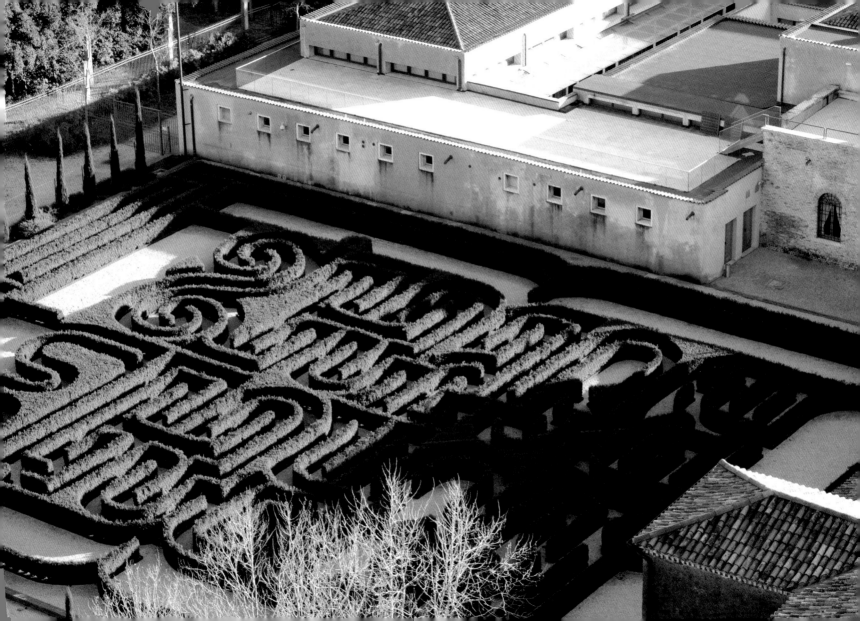

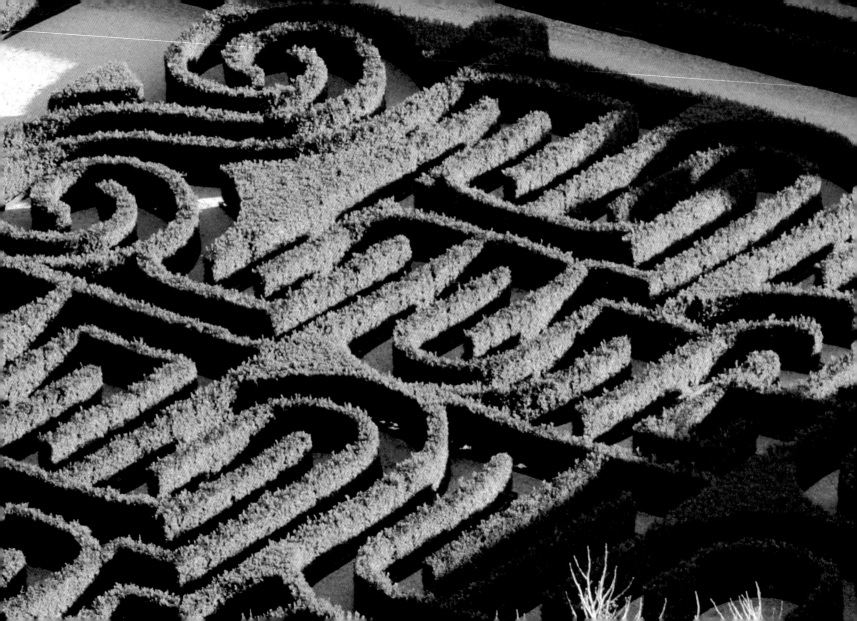

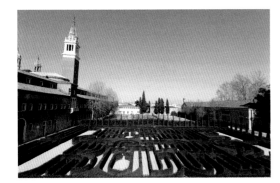

"I met Borges through Susana Bombal and she came with me to that first meeting. It was the first time I'd seen him, and I realized that he was blind, which was very upsetting. I was very conscious of speaking to a blind person, and that I could see but he could not. Five years before Borges died, I had a dream in which I heard that Borges had just died. And I thought to myself, I must make sure that Borges is not memorialized with one of those terrible statues— a depiction of angels or something. He has to be honored with something truly Borgesian, in other words, a labyrinth. That's when I began to design it and think about it and dream up a shape for it— an extraordinary labyrinth for a man with an extraordinary mind."
—Randoll Coate

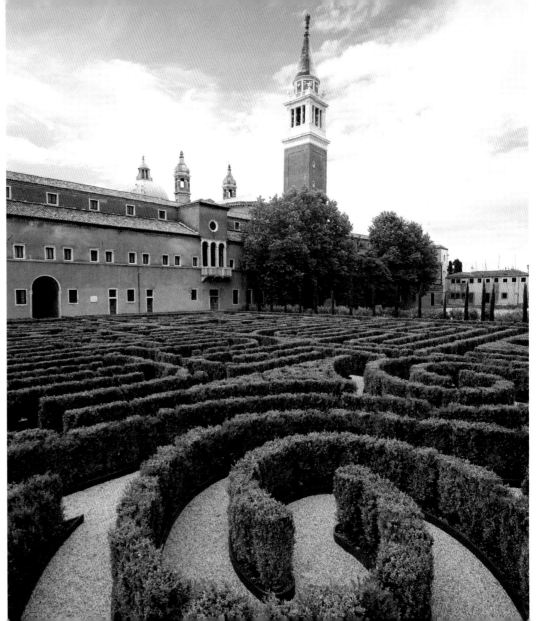

Villa Arvedi Maze

- **Designer:** Giovan Battista Bianchi
- **Location:** Villa Arvedi di Cuzzano, Grezzana, province of Verona, Italy, 1650
- **Material:** boxwood hedges

Seventeenth-century Italian architect and landscape architect Giovan Battista Bianchi designed Villa Arvedi and its gardens as they still stand today. The architect was clearly influenced by Renaissance garden design with its typical symmetrical, axial layout.

The resulting work is a masterpiece of subtlety that combines the spirals and curlicues of a classic Renaissance garden with a path that winds around itself, twists, and turns until it reaches the very center of the garden. The manicured hedges of the maze offer a clear view of the path, which doubles back on itself and zigzags from left to right. Once visitors have reached the center of the maze, they are treated to a full-on view of the villa's front facade.

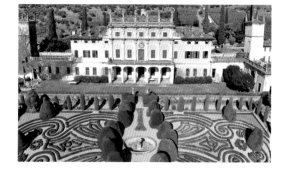

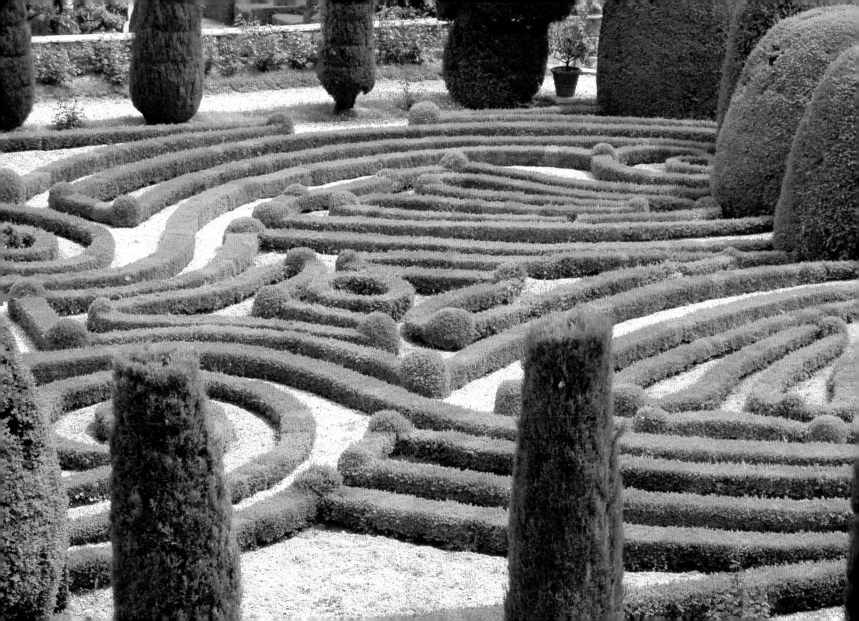

Villa Pisani Maze

- **Designer:** Girolamo Frigimelica
- **Location:** Villa Pisani, Stra, Veneto, Italy, 1721
- **Material:** originally planted with hornbeam and linden hedges (replaced by boxwood)

The Villa Pisani maze is one of the best-surviving examples of a Renaissance maze. It was designed by poet-architect Girolamo Frigimelica, who also built the imposing villa in whose gardens it is located. Today guides help visitors find their way around the maze's intricate paths. Without their help, it can be very difficult to locate the exit, and there is evidence of damage wrought by those incautious souls who tried to make it on their own and at a certain point, surrounded by tall boxwood walls and unable to see over them, desperately tromped through the hedges to escape.

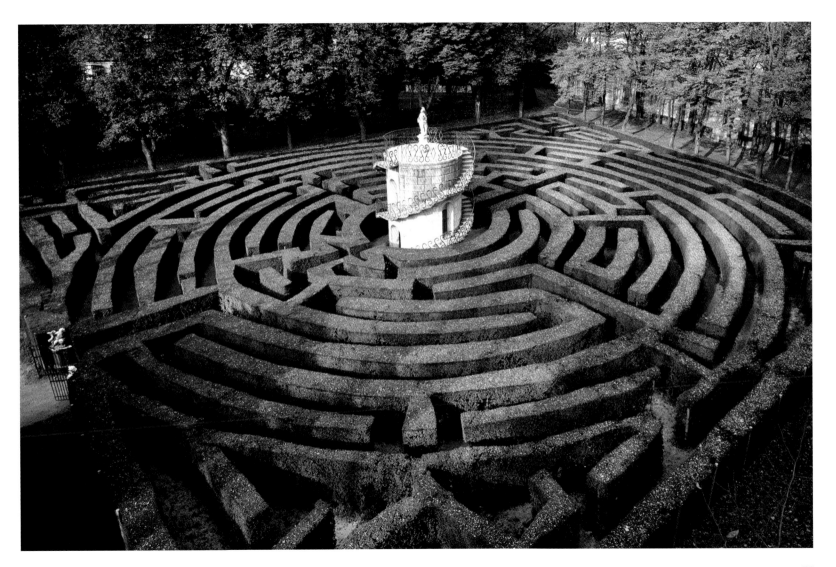

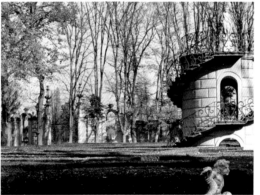

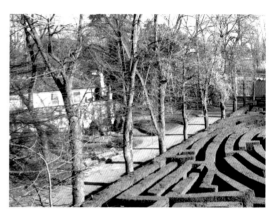

The maze consists of nine concentric rings and is bordered on the north by linden and on the east by hornbeam hedges. Its uniform curved tall walls are a source of great confusion. At the center of the maze is a tower with a spiraling external staircase leading up to a lookout platform. Here visitors can orient themselves and commit to memory key reference points.

The park around the maze is beautiful, and some of its main elements can serve as additional landmarks for visitors. But standing in the tower and looking around can also cause no small amount of intimidation, as it dawns on visitors that they'll now have to find their way back out.

Legend has it that during the eighteenth century the first person to make his way through the maze would be greeted under a pergola in the center tower by a lovely young woman wearing a veil—his reward for figuring out the puzzle.

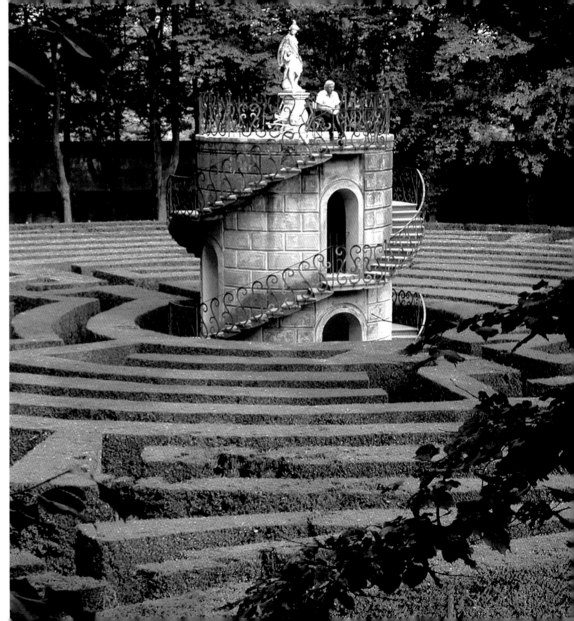

Hampton Court Maze

- **Designers:** George London and Henry Wise
- **Location:** Hampton Court Palace, London, UK, 1690
- **Size:** trapezoid in shape with the longest side measuring 229.6 feet (70 meters)
- **Material:** white hornbeam, holly, privet, and yew hedges

Commissioned by King William III of England, the Hampton Court maze is one of the most famous and most visited Renaissance hedge mazes still in existence. Other than the examples in Italian-style gardens, which were typically just one manicured element within a geometric and tightly designed landscape, the mazes in English-style gardens contrasted with more untamed environments.

The Hampton Court maze consists of a fairly simple layout, with few dead ends. It is relatively easy to reach its center and to make your way back out by keeping the hornbeam wall always to your right. This method also allows visitors to get out of cul-de-sacs when they take a wrong turn. The maze is believed to be one of England's oldest multicursal mazes.

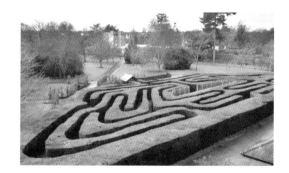

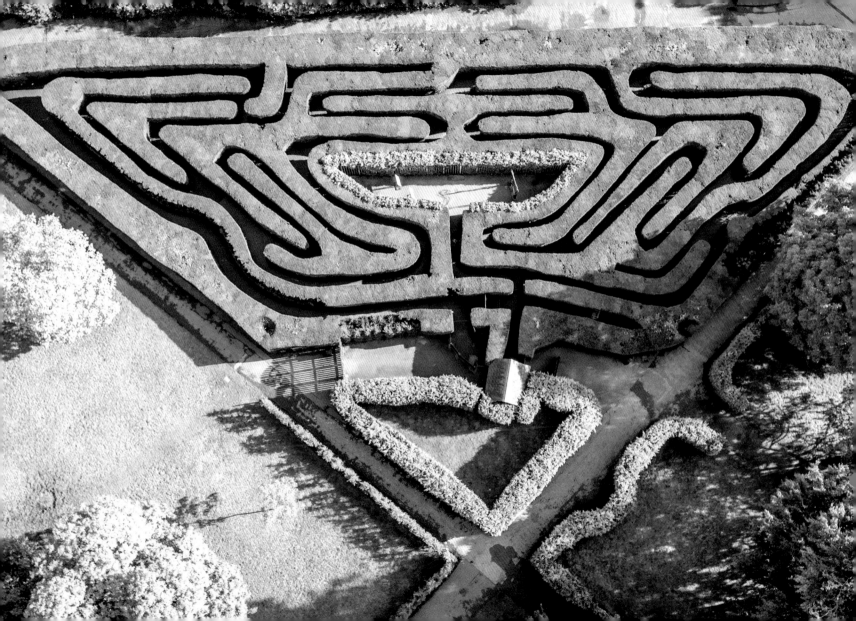

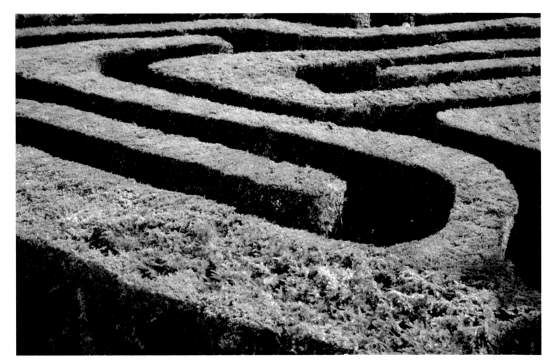

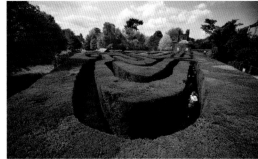

Its layout has never been altered; the hedges themselves, however, are constantly changing. As living organisms, they are susceptible to disease and frequently die off in winter. Therefore, though in theory the hedges are supposed to be all white hornbeam, in practice holly and privet have been grafted in, and later yew hedges were added as well, because they are stronger and easier to maintain.

The habitat outside the maze was once as wild and confusing a tangle as the maze itself. Today the surrounding plants are carefully maintained, and several different species of flowers bloom in spring.

Longleat House Maze

- **Designer:** Greg Bright
- **Location:** Longleat House, Horningsham, UK, 1975
- **Size:** 1.48 acres (0.6 hectares) with 1.75 miles (2.7 kilometers) of paths
- **Material:** 16,000 yew trees

One of the largest in the world, this maze located near Elizabethan Longleat House is made of hedges almost 10 feet (3 meters) high that wind around to create numerous dead ends and forking paths. It is no easy task to locate its exit, and even if you never made a misstep, traveling the entire maze would take more than an hour and a half. To make the journey in and out easier for visitors, the complex maze is outfitted with numerous elevated platforms that allow visitors to step above the paths between the dense hedges and see the maze from a bird's-eye view to orient themselves. There are also emergency stations located strategically along the path. If people get lost and start to panic, they can stop at one of these and use a phone to summon a guard for assistance.

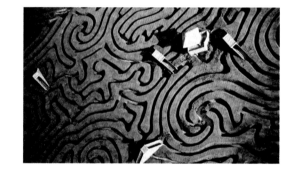

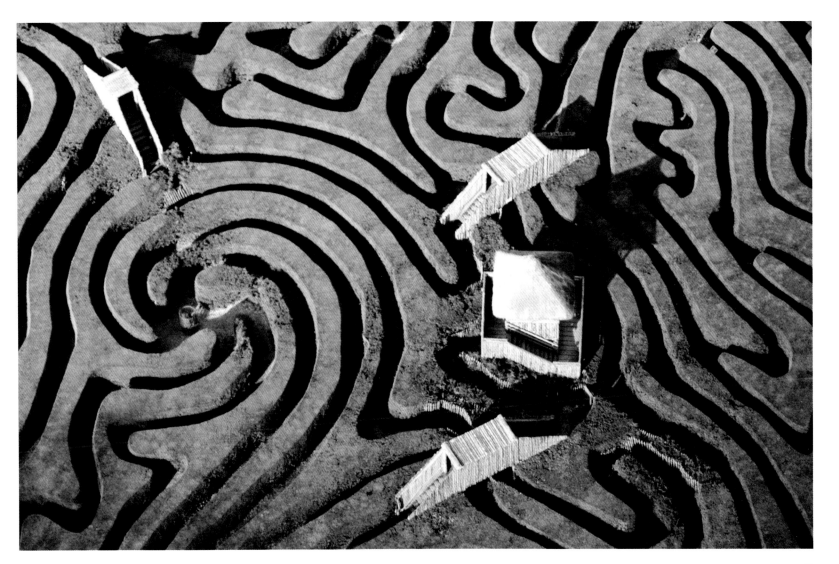

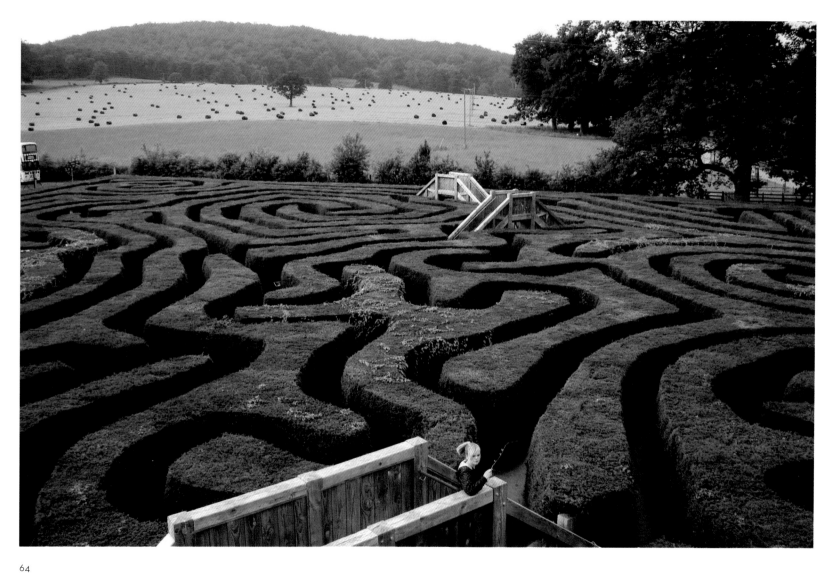

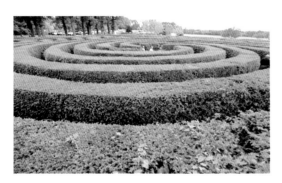 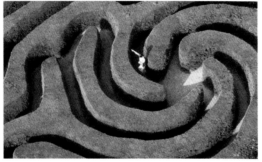

The layout is extraordinarily complex. Many of the paths curve one way and then another, drawing concentric circles, spirals, and loops of various sizes. Most of the dead ends are generated by spirals in the path that loop around themselves and end in plant-walled enclosures within the maze. When you are standing in one of these, the feeling of isolation is palpable.

Maintenance of the maze is even more complex than the maze itself: six gardeners must keep on top of growth and prune all the plants by hand every six months, making sure not to get lost in the maze themselves while performing this task.

Hever Castle Maze

- **Designers:** Joseph Cheal and Son
- **Location:** Hever Castle, Kent, UK, 1904
- **Material:** yew hedges

Hever Castle was once home to the family of Anne Boleyn, the second princess consort of King Henry VIII. The last owner who used it as a residence was magnate William Waldorf Astor, who commissioned the design of an Italian-style garden at the castle. He used it as an open-air museum to display statuary and sculptures from his massive art collection. In addition to the garden's many other features, it includes a maze in the seventeenth-century and Renaissance traditions. Indeed, Astor was just one of several wealthy people of his era who had a passion for mazes as entertainment and commissioned them for their gardens. The Hever Castle maze is a multicursal maze, and visitors have to put in some effort and thought to reach its center.

The castle was conceived initially as a defensive structure surrounded by a moat. The gardens, which were created much later, connect the fortress to the surrounding landscape and soften its austere nature. The farms on the land surrounding the castle also help integrate the architecture into the environment.

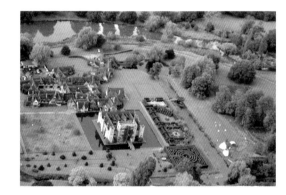

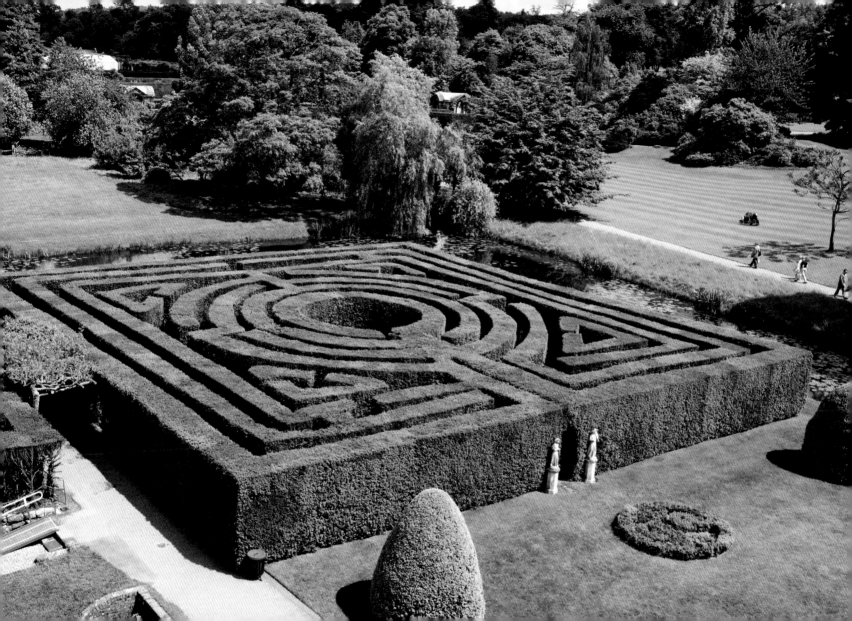

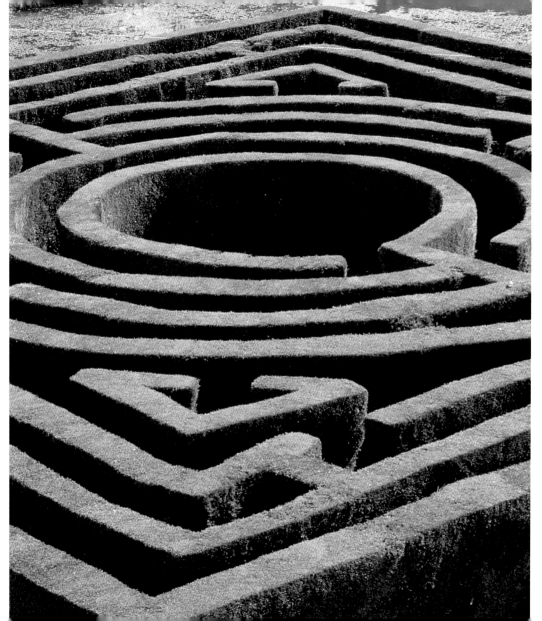

The yew hedges that form the walls of this maze are carefully maintained and trimmed to keep its shape precise.

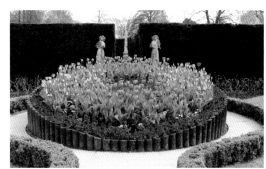

The geometry of the maze design, with its angular hedges, contrasts with the more recent "natural garden" that surrounds the maze with a mix of various untrimmed hedges and trees. The splendid maze rests on a neatly manicured lawn, which almost seems to warn off visitors: the maze may look orderly and clear from the outside, but on the inside things will be different—you may get lost. The wrought-iron gate that marks the entrance to the maze is flanked by two marble statues. Passing through the gate feels like entering a secret room cloaked in mystery.

Schönbrunn Maze

- **Designer:** unknown, commissioned by the Habsburg family
- **Location:** Schönbrunn Palace, Vienna, Austria, 1698–1740 (re-created in 1998)
- **Size:** 18,640 square feet (1,715 square meters)
- **Material:** yew hedges

It is not hard to imagine the emperor and empress of Austria strolling through the sumptuous gardens of the Schönbrunn Palace in Vienna, or trotting on horseback across the perfectly manicured lawn, or even venturing into the palace's historic hedge maze. The original maze fell into disrepair during the nineteenth century, when its maintenance was neglected, and its last hedge was raised in 1892. In 1998 a copy was created based on plans of the original design found in the palace archive.

The maze has several paths, only one of which leads to the center, which is marked by an old plane tree and a viewing platform. Once visitors reach the center, they have an overview of the maze and can see how to retrace their steps back to the exit.

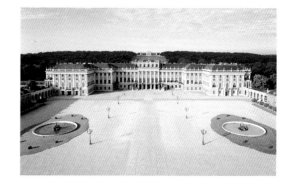

The imposing face of Schönbrunn Palace hints at the pomp and splendor of the interior and the gardens. The latter are largely baroque and Italian style but also reflect other influences, with a Japanese corner and parts designed in a Romantic style. The maze is a focal point of the gardens and a source of fun and entertainment for visitors.

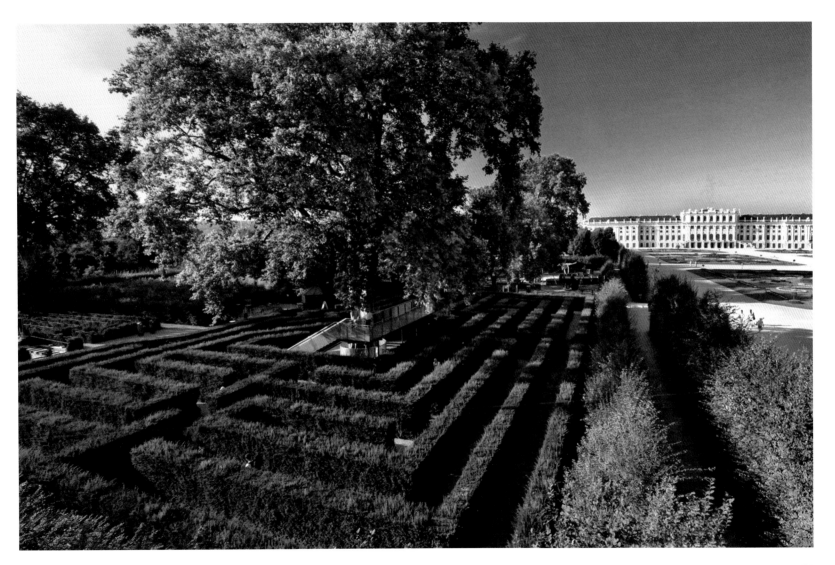

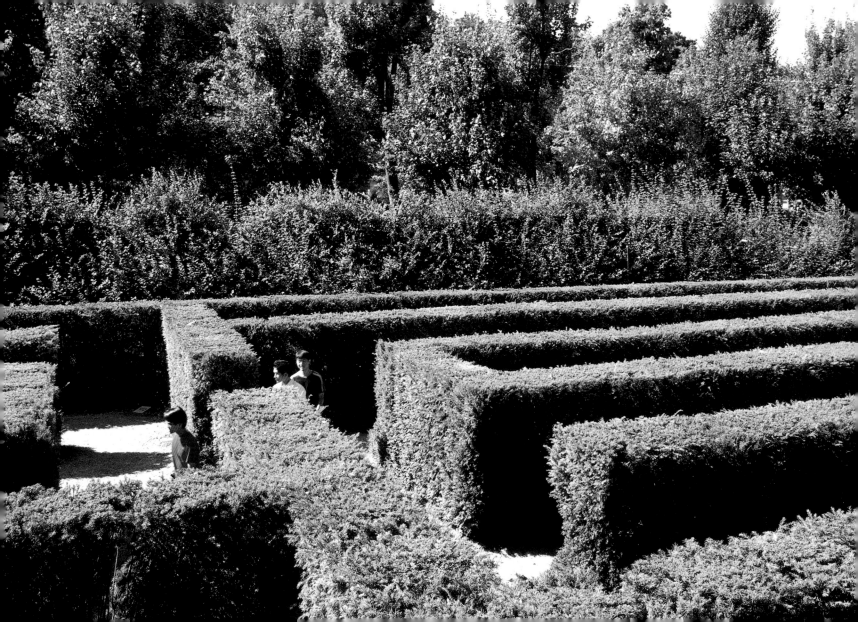

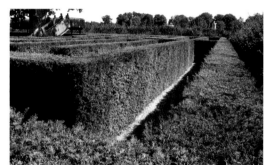

The maze is a fine example of the Renaissance tradition with its many forking paths. As visitors make their way to the center, they can enjoy getting lost and then finding their way again, pausing to rest in the small niches created by the numerous dead ends.

Originally, the maze had a raised pavilion at its center, which provided a view from above. These days the maze also includes a number of stones carved with the twelve signs of the zodiac placed amid the hedges. At the foot of the plane tree at the center are two "harmony stones" symbolizing the flow of energy between rock (cosmos/earth) and mankind.

Menkemaborg Maze

- **Designer:** unknown
- **Location:** Uithuizen, province of Groningen, Netherlands, early eighteenth century
- **Material:** hornbeam hedges

Menkemaborg is one of the finest examples of Renaissance architecture in the Netherlands and one of the loveliest of the sixteen historic houses scattered throughout the province of Groningen. It was originally built as a fortress in the fourteenth century, as evidenced by the fact that it is surrounded entirely by water so that unwelcome guests could not approach. The castle underwent intense restoration work around 1700, which opened up the architecture to the surrounding countryside. A key part of this was a redesign of the grounds as Italian-style gardens, including the addition of a hedge maze with multiple paths and a magnificent tree at its center.

The aerial photo of Menkemaborg at right provides a view of the beautifully preserved residence of the Alberda family and its Renaissance gardens, including an Italian-style garden, a kitchen garden, and the maze.

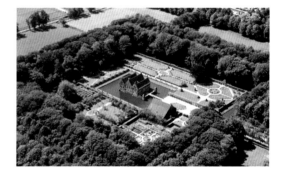

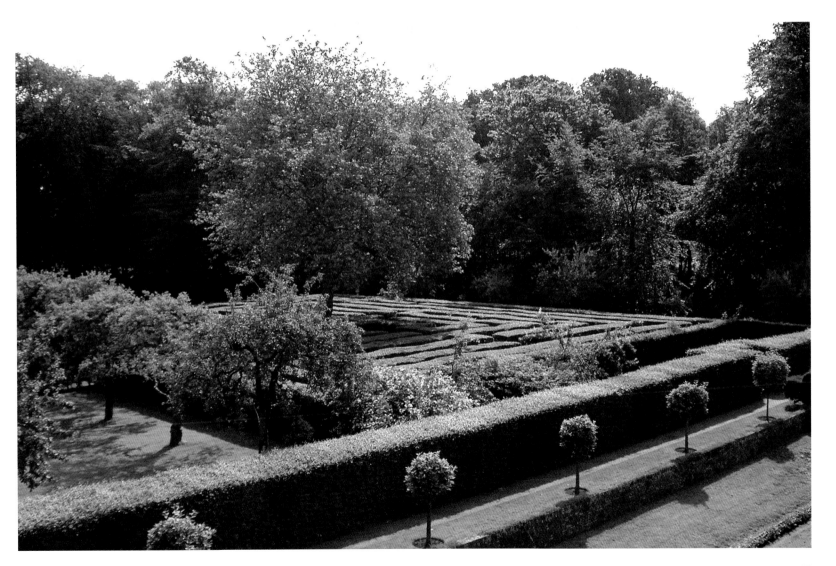

Traquair Maze

- **Designer:** John Schofield
- **Location:** Traquair House, Innerleithen, UK, 1981
- **Size:** more than half an acre
- **Material:** originally planted with Leyland cypress hedges (replaced with beech trees in 1983)

Traquair House, which dates back to 1107, when it served as a hunting lodge for Scottish royalty, is one of the oldest aristocratic villas in Scotland and Scotland's oldest continually inhabited house. The maze in its gardens is much younger, having been created in 1981 to draw visitors.

John Schofield, a local craftsman, designed and planted the maze at the rear of the house. At first glance, it looks like a typical Renaissance maze with multiple paths, but upon closer inspection it is revealed to be in a more modern style. One unique facet is that in order to reach the center of the maze, visitors must pass through the center of each of the four quadrants first.

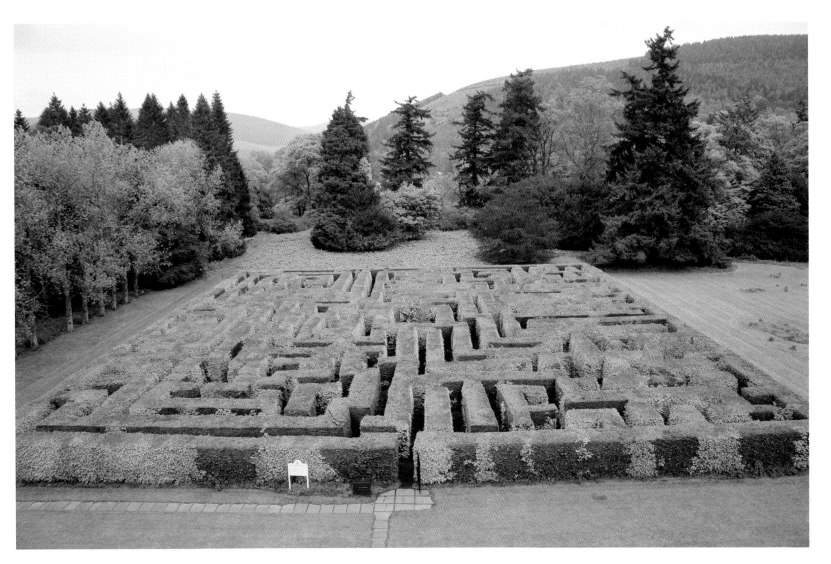

Harmony Labyrinth

- **Designer:** likely Frederick Rapp, one of the founders of the Harmony Society and an architect
- **Location:** New Harmony, Indiana, USA, originally designed in 1815 (re-created in 1939)
- **Size:** 140 feet (42.6 meters) in diameter
- **Material:** originally planted with a combination of various kinds of hedges, vines, and flowering bushes (re-created with privet hedges)

The Harmony Labyrinth was originally planted by members of the Harmony Society, a Christian theosophy society with German roots, in 1815. The numerous paths of this hedge maze symbolize man's difficulty in his earthly journey toward harmony and perfection. In the center of the labyrinth is a small building known as the grotto. Reaching the grotto symbolizes reaching the state of peacefulness that only the Harmony Society can provide.

The society created hedge mazes in each of the three towns they settled between 1805 and 1905, but none of the original labyrinths survived. The maze at New Harmony is a recreation based on architectural drawings of the original.

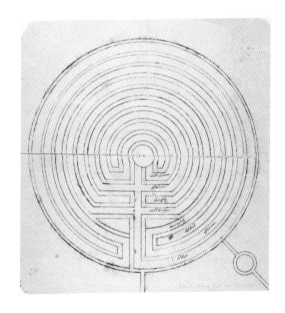

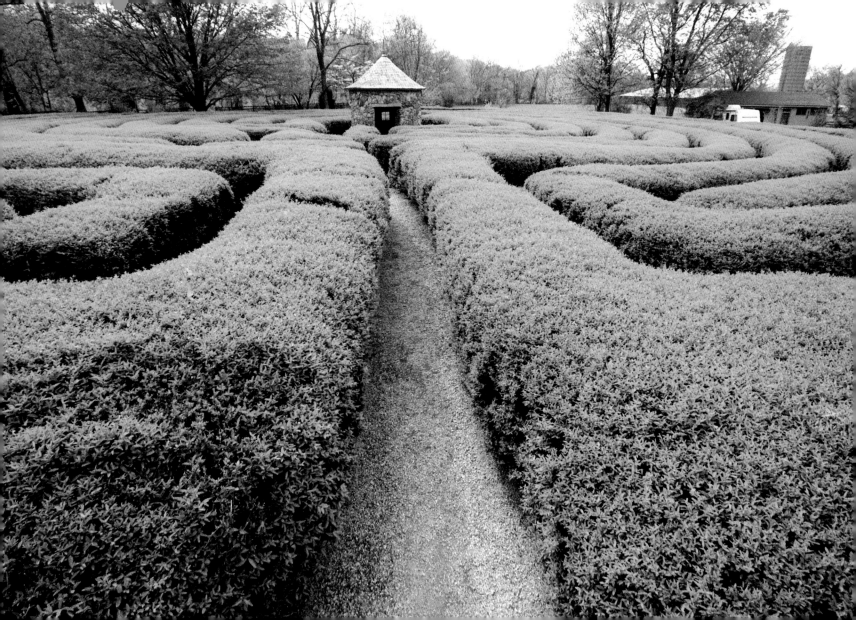

Labyrinth

- **Author:** Olaf Nicolai
- **Location:** Parc de La Courneuve, Seine-Saint-Denis, France, 1998; Galerie für Zeitgenössische Kunst, Leipzig, Germany, since 1999
- **Size:** 2 x 32.8 x 32.8 feet (6 x 10 x 10 meters)
- **Material:** bristles from Paris street sweeper brooms

 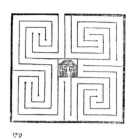

178 179

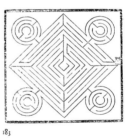 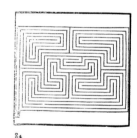

183 84

This installation by German conceptual artist Olaf Nicolai is intentionally provocative. It plays off the idea of traditional mazes found in the gardens of French aristocratic residences of the eighteenth century, but its placement in a public park in a suburb of Paris with a large immigrant population raised questions about changing concepts of urbanism and the politics of migration. Additionally, rather than creating his labyrinth with carefully trimmed boxwood hedges, Nicolai used bristles from the bright green plastic brooms that Parisian street sweepers use to clean the streets—a type of work generally performed by members of the working class and often by immigrants.

The pattern of *Labyrinth* is a variation on a baroque-era design found in Daniel Loris's book *Le Thrésor des Parterres de l'Univers*, published in 1629.

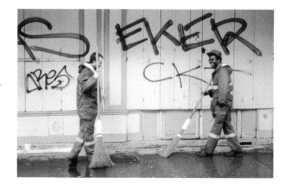

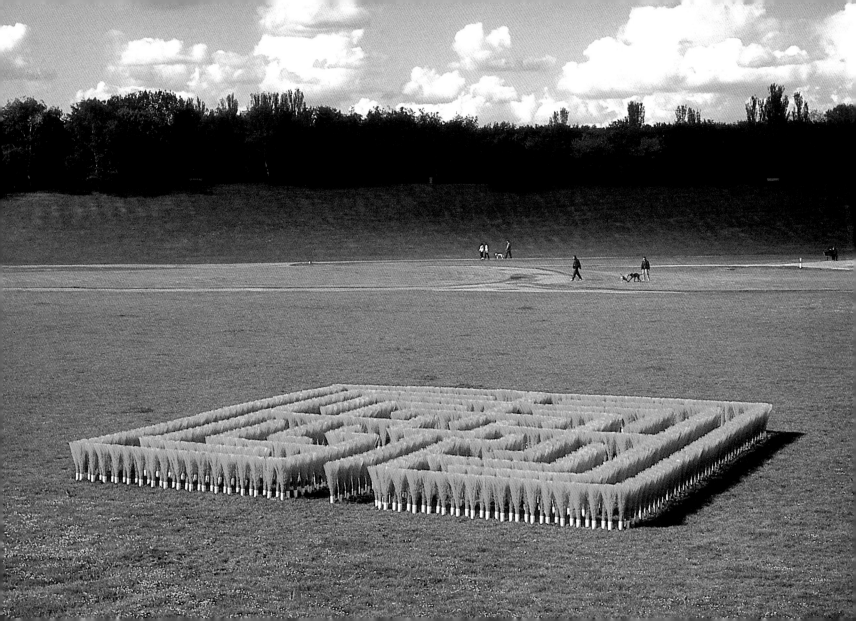

Zig Zag Maze

- **Designer:** Richard Fleischner
- **Location:** Rehoboth, Massachusetts, 1972
- **Size:** 3 x 8 x 49 feet (0.9 x 2.4 x 14.9 meters)
- **Material:** sudangrass

Cornfield mazes are part of a long American tradition. Farmers create these mazes in their fields using tractors in order to earn additional income from their large swaths of corn. These mazes attract visitors, who enjoy getting lost and then finding their way out from among the tall corn plants. Farmers often compete with each other to create the best mazes; many of them are so large that they can only be viewed in their entirety from the air.

Richard Fleischner began experimenting with his variation of a cornfield maze in 1972, in a field of sudangrass, normally grown as animal feed. He created a pattern within the field by using a technique of placing canvases in places where he did not want the plants to grow. This enabled him to work on three levels: the earth itself, the field, and the grass. The precursor to *Zig Zag Maze* was *Bluff* (pictured top right), where Fleischner developed this technique (Rehoboth, Massachusetts, 1972).

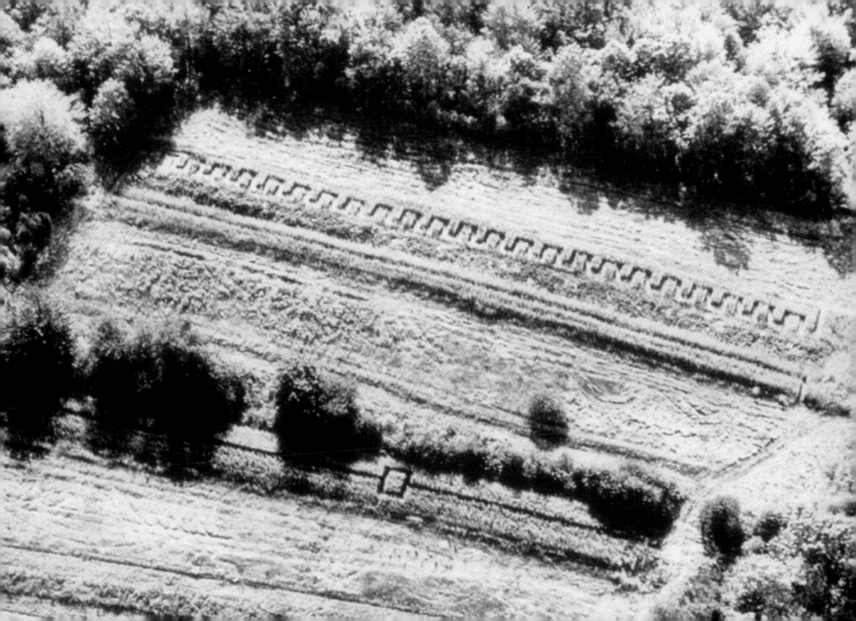

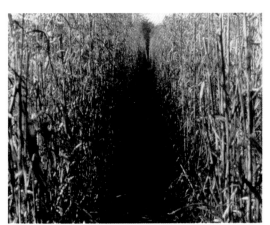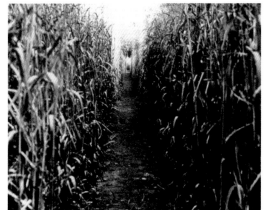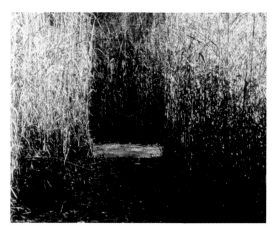

The maze consists of a zigzagging path paired with a parallel return path about 370 feet (113 meters) long. At each turn you can pick up the return path and go back to the starting point. The *Zig Zag Maze* is unique in its layout of a single path without dead ends or even a center. The simple but elegant composition with repeated ninety-degree turns in the path bordered by plant walls that grow up to 6.5 feet (2 meters) tall provides a subtle sense of disorientation, although you cannot really lose your way.

Fleischner riffed on traditional labyrinth designs with his *Zig Zag Maze*, distinguished largely by the fact that its path does not form concentric loops but is a linear realization of the Greek motif that could go on infinitely. Like many cornfield mazes, this maze can be seen in its entirety only from above. When you are on the ground inside the maze, it is easy to lose your bearings. The paths are bordered by tall plant walls that cause the same feelings of confusion and disorientation experienced in other mazes and labyrinths, even though the path to follow is straightforward.

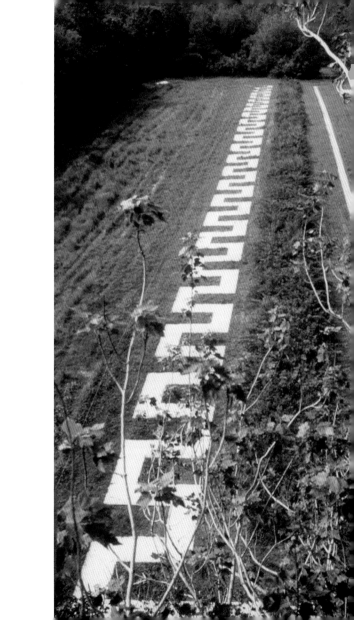

Iron Knot

- **Designer:** Lucien den Arend
- **Location:** Polder, Hardinxveld-Giessendam, Netherlands, 1992
- **Size:** 72 x 656 feet (22 x 200 meters)
- **Material:** 200 white willows

Dutch artist Lucien den Arend created this labyrinth on an island located next to the county museum. The artist's aim was to create a "labyrinth in motion," with a path that would change over time. Two hundred willows were planted 3 feet (1 meter) apart. Initially, the distance between the young willows made it possible to enter the labyrinth from anywhere on the outside and to see the entire path at once. Over time, the spaces between the trees have grown more and more narrow, making the labyrinth increasingly impenetrable. Eventually, the only way to experience it will be to travel along the spiral path that leads to the center. That experience will also become increasingly disorienting as the trees grow. The path will no longer be fully visible, but visitors will get a glimpse of it here and there between the dense willow branches.

Every three years, the tops of the willows are trimmed to a height of 6.5 feet (2 meters), slowly forming a kind of roof for the labyrinth.

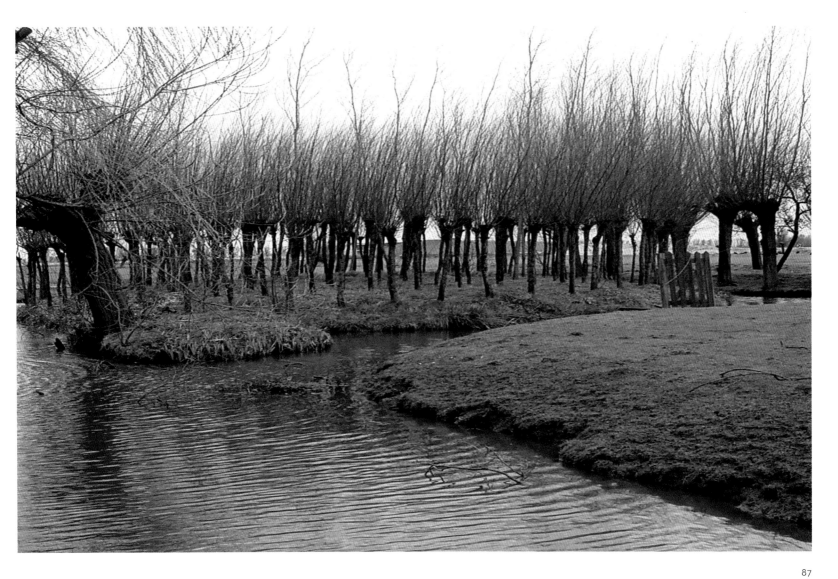

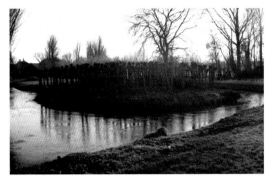

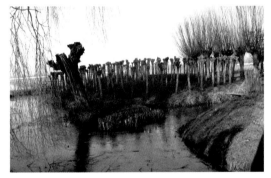

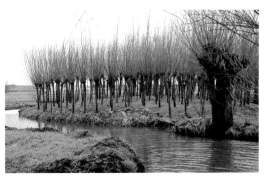

"When I began to think about this project, I had already been using willows as a sculpture material for at least twenty years. I had always used trees to create spaces that could be entered both physically and mentally. The fact that these were labyrinths for me added another dimension, because it forced me to focus on the experience a visitor faces when he comes into contact with one of these projects. The aim is not to confuse or disorient people, but simply to get them to understand the idea behind each installation and find a new solution each time. The Hardinxveld-Giessendam labyrinth was specifically made for children, to stimulate their imaginations. Laying out the labyrinth and determining how to plant the willows in the soft polder soil took an entire day. I found an old basket once used to collect feed and placed it in the middle of the island. I attached a rope to the basket and planted the first willow on the perimeter of the island next to a temporary walkway of wooden planks. Using the rope to measure the distance, I planted the willows one meter apart, turning the rope clockwise as I went. When I got to the middle, I planted the two hundredth willow. As time passed, the willows grew, so now the only way to get through it is to walk along the spiral path clockwise."
—Lucien den Arend

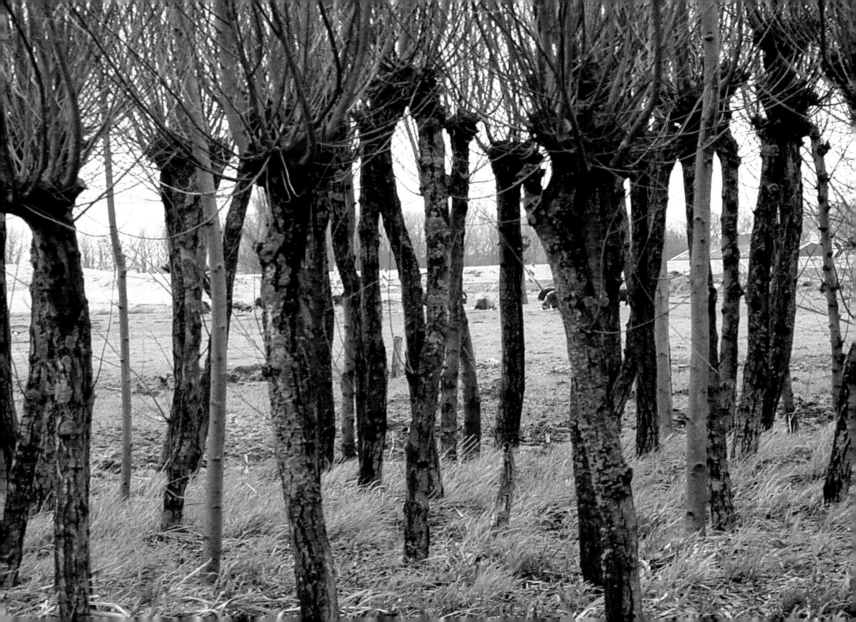

Sunflower Maze

- **Designer:** a local family
- **Location:** Holzgerlingen, Germany, 2003
- **Size:** approximately 131 feet (40 meters) in diameter
- **Material:** sunflower seeds, soil for mulching, and wool fiber

The Renaissance tradition of hedge mazes still wields influence today. Located in gardens or parks and built with natural elements, they offer a chance for young and old alike to amuse themselves. In recent years, such mazes and labyrinths have developed a cult following among people with sizable gardens and farmers with fields or large tracts of land. Out in the country, they crop up seasonally and for just a few weeks become temporary amusement parks for locals and tourists.

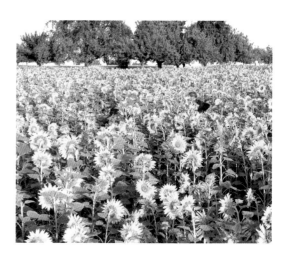

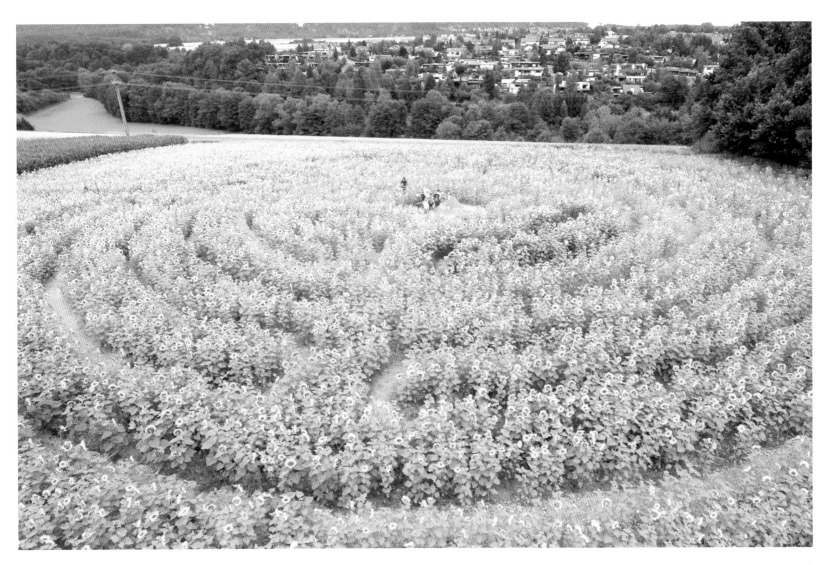

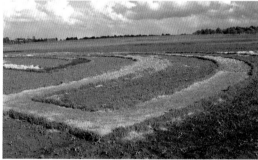

This labyrinth, planted by a family in Germany with the help of community members, is based on the classical tradition of a unicursal labyrinth, with one path winding around itself to reach a central "room." Clearly, in order to emerge from the labyrinth, all you have to do is retrace the same path in reverse. What is unique about this labyrinth is that it was created using a clever technique for planting sunflowers developed over the years. First the labyrinth's outer border is traced in the soil. Then a rope is tied to a stick at the center of the labyrinth and wound around it to draw concentric circle paths. Both the paths and their walls are mapped out this way. The dark brown soil pictured above is where the sunflowers will be planted. The lighter brown areas will become the labyrinth's path.

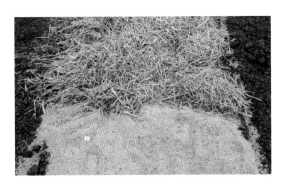

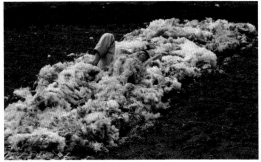

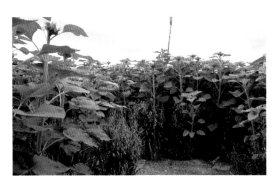

The path consists of packed dirt that rests on a base of hay and sawdust, which both distinguishes the path by giving it a different feel and also results in a soft surface for visitors to walk on. Wool fiber protects the seeds from harsh temperatures and excessive sunlight. The different materials lend each section a different feeling.

The entire community enjoys seeing the labyrinth grow taller and taller as spring turns into summer. Children, especially, love playing among the sunflower plants.

Labyrinth

- **Designer:** Jan Krtička
- **Location:** near Olomouc, Moravia, Czech Republic, 2001
- **Size:** 6 x 26.2 x 39.4 feet (1.8 x 8 x 12 meters)
- **Material:** thin nylon thread and fallen leaves

It took Czech artist Jan Krtička many walks through the countryside around his native city in the east of the Czech Republic to find the ideal spot for his labyrinth of leaves. He finally placed it in a small grove of young trees that is part of a larger forest of centuries-old trees. The challenge was to create a distinct area within the larger and potentially overwhelming environment.

The labyrinth almost seems hidden in the forest, but the artist managed to create a clearly defined space with his walls of leaves that are held together with nylon thread and anchored to trees standing varying distances apart from each other. The unusual labyrinth was inspired by the simple unicursal design of ancient pagan labyrinths, which were common throughout the Czech Republic.

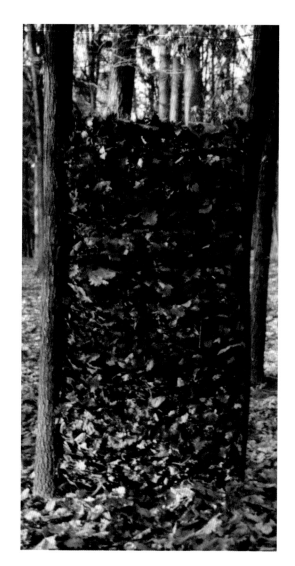

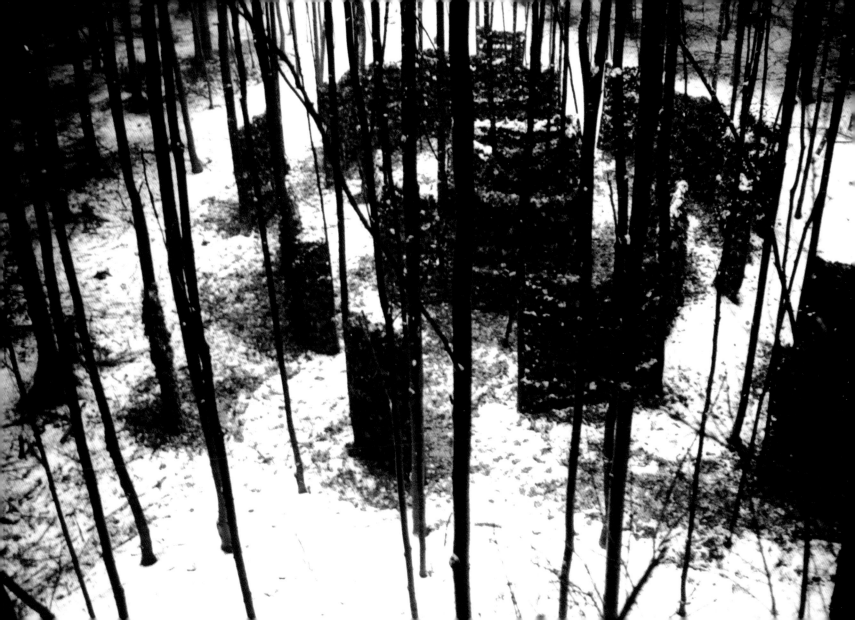

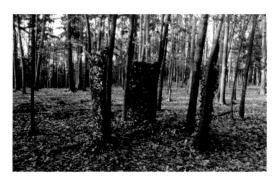

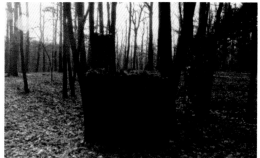

Construction began in the center, where there is a kind of sacred space. This intimate spot is remote from the surrounding environment and provides a place for visitors to be in touch with themselves and their fears while being sheltered from the chaos of the outside world.

The part of the forest in which *Labyrinth* is located is characterized by thin tree trunks laid out in a precise grid. Although Krtička's installation has a light, temporary character, it manages to establish a circumscribed, protected, and safe place amid the vastness of its undifferentiated setting.

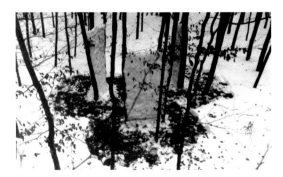 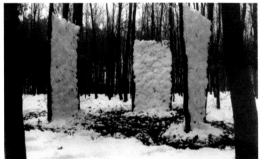 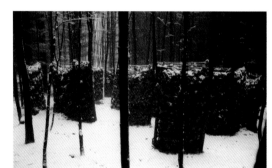

For the artist, the forest grid symbolizes order. But in fact, although the tree trunks are located at regular intervals, the grid can be disorienting. It is hard to tell where it begins or ends, making it impossible to distinguish between being inside or outside.

Labyrinth is based on a binary concept. The grid, the orderly element, represents monotony—things remaining the same yet generating confusion.

Set within this grid, the labyrinth creates distance and acts as a specific and defining element. It establishes a closed space within an open space, an inside and outside, and delineates the private from the public.

Simplified Mirror Labyrinth II

- **Author:** Jeppe Hein
- **Location:** Kunstverein Kehdingen, Freiburg/Elbe, Germany, 2005
- **Size:** 7.5 x 26.2 x 26.2 feet (230 x 800 x 800 centimeters)
- **Material:** steel frame, PVC, high-polished stainless steel (super mirror)

Danish artist Jeppe Hein created this labyrinth for an exhibition at the Kunstverein Kehdingen in Freiburg/Elbe, Germany. The work is more reminiscent of the fun-house mirror mazes of amusement parks than the plant mazes of Renaissance gardens. The mirrors disorient with refraction and reflection and cause the setting to dissolve. They reflect the path with its turns and dead ends, multiplying it infinite times, and break up the surroundings into small fragments that change as visitors move through the labyrinth. In order to locate their position in the landscape, they must piece those fragments together.

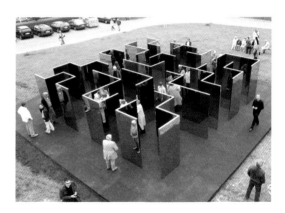

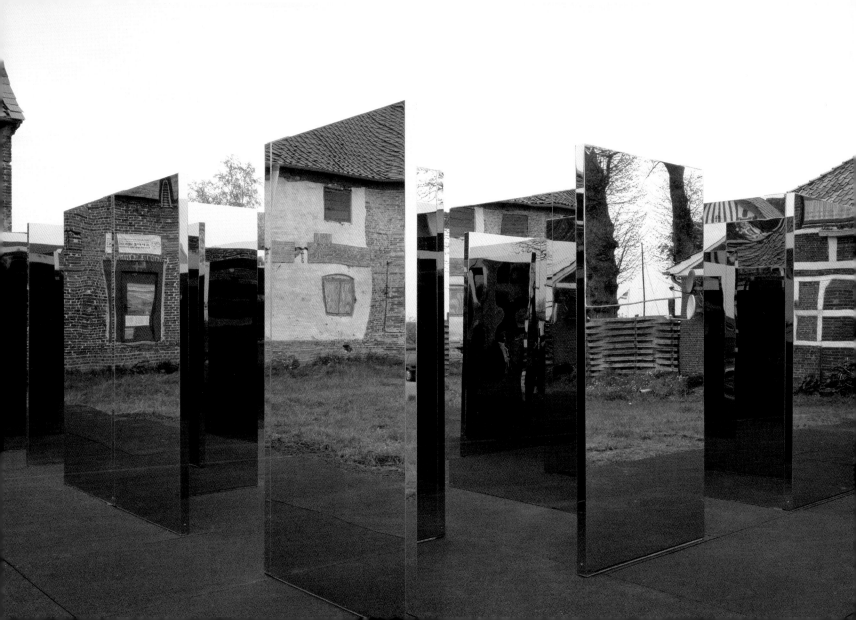

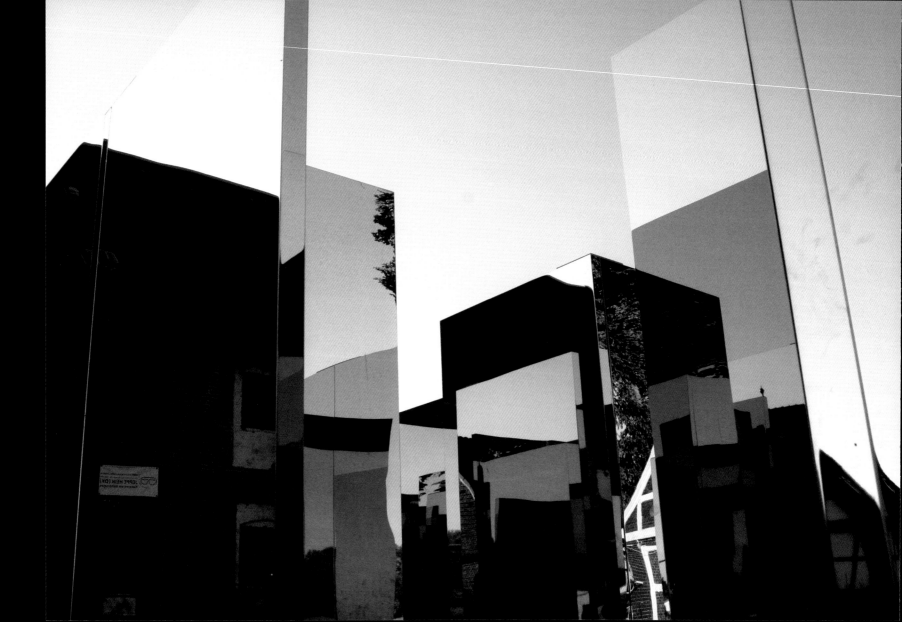

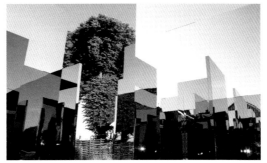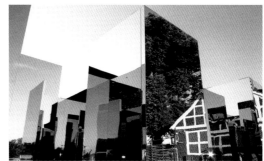

Similar to a Greek labyrinth, the work has a square design and various geometric paths that intersect. There are no walls around the perimeter, however, making it possible to enter and exit this labyrinth at any point and opening it up to its surroundings, fostering greater interaction between the visitor, the labyrinth, and the landscape.

Installed in a public space, this labyrinth is all about triggering a reaction. Its multiple entry points, the mirrors, and the difficulty of distinguishing between what is really there and what is a reflection combine to create a heightened sense of disorientation.

3-Dimensional Labyrinth

- **Author:** Jeppe Hein
- **Location:** Anyang Public Art Project, Anyang, Korea, 2005
- **Size:** 26.25 feet (8 meters) in diameter; 7.2 feet (2.2 meters) in height
- **Material:** steel frame, PVC, high-polished steel (super mirror)

This labyrinth by Jeppe Hein was made of a number of mirrored lamellae. These lamellae form three concentric circles with openings that can serve as either entrances or exits and make it possible for visitors to see through the entire installation, giving it a sculptural feel. The lamellae reflect one another, the people within the labyrinth, and the surrounding countryside. The mirrored elements are thus easily confused with the natural environment, and it becomes almost impossible to distinguish between the two. The labyrinth physically and psychologically tests people's awareness as they walk through it, leading to an energized and dynamic interaction with the piece.

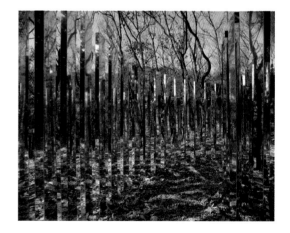

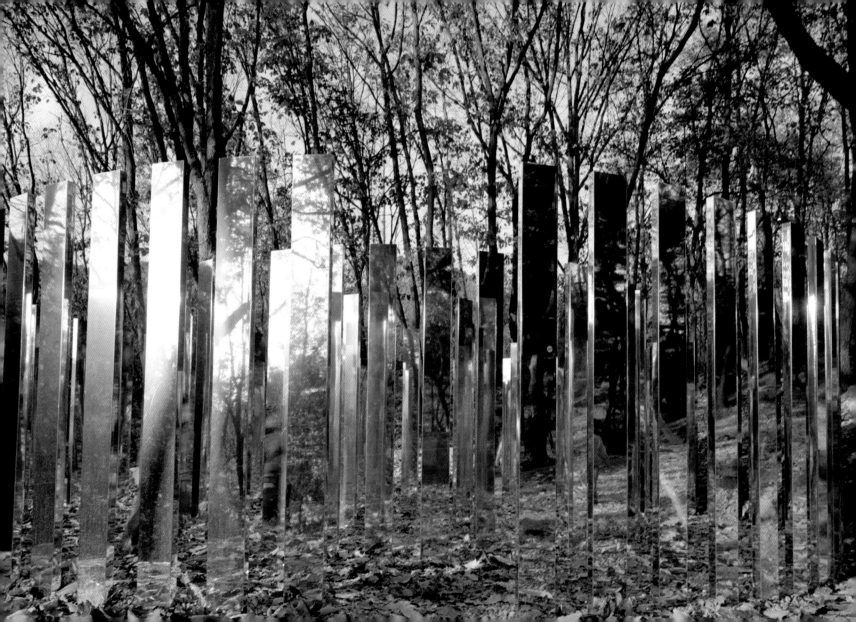

Via Negativa II

- **Designer:** Lee Bul
- **Location:** Lehmann Maupin Gallery, New York, New York, USA, 2014
- **Material:** polycarbonate sheet, aluminum frame, acrylic and polycarbonate mirrors, steel, stainless-steel, mirror, two-way mirror, LED lighting, silkscreen ink

Korean sculpture and installation artist Lee Bul explored the concept of awareness in a 2014 exhibition at Lehmann Maupin Gallery, which included several pieces of her recent work. One was this labyrinth, a meditation on how a large part of our self-awareness is based on reflection. Quotes by psychologist Julian Jaynes about self-awareness were printed on the mirrored walls. The text was written in reverse so that people walking the labyrinth could only grasp a few words at a time, which then became a key element in their experience of the labyrinth.

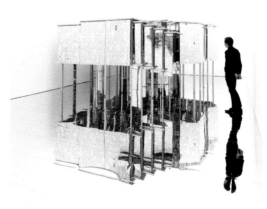

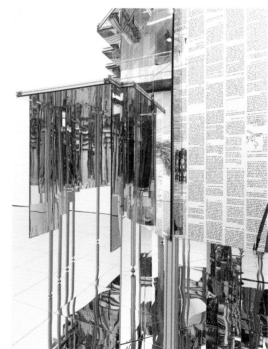

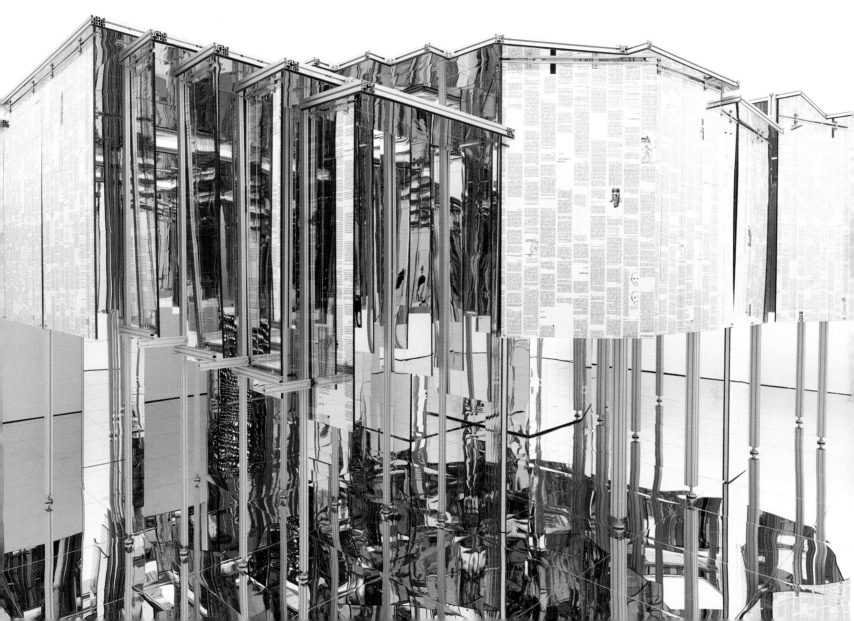

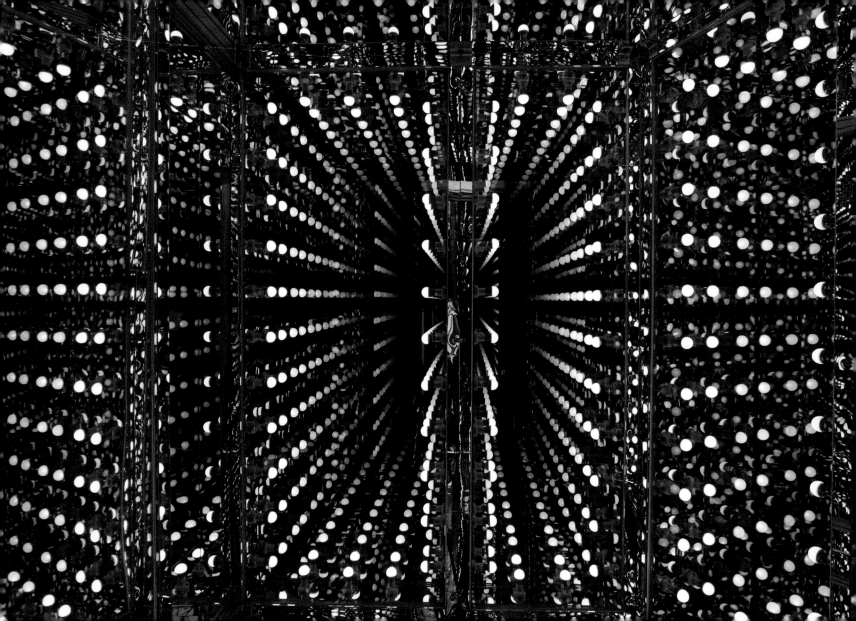

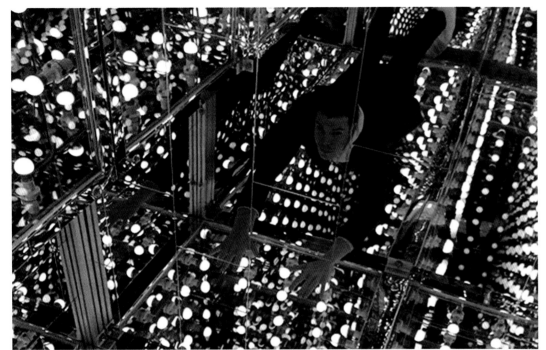

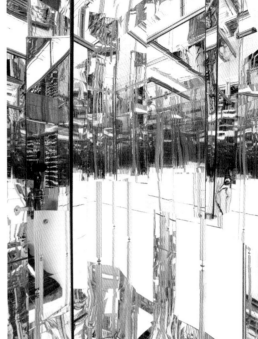

Although the path was straightforward, the mirrors and the infinite reflected images they generated created many imaginary routes and caused those inside the labyrinth to see themselves in a fragmented way. Occasionally, larger mirrors allowed visitors to see themselves in full, increasing their self-awareness.

The labyrinth thus functioned as a device to address people's sense of self by fragmenting it. Then they could recapture it by moving on, eventually making their way through the labyrinth. With her installation, Lee addressed questions and doubts about existence, prodding visitors to consider these subjects.

Greek Cross Labyrinth

- **Designer:** Dan Graham
- **Location:** Skulpturenpark, Cologne, Germany, 2001
- **Material:** stainless steel and glass

Since the late 1970s, the New York–based conceptual artist Dan Graham has been using glass walls and mirrors for a variety of pavilions and other architectural pieces that create complex and poetic moments of self-observation for visitors. *Greek Cross Labyrinth* was made for a sculpture park in Cologne, Germany, in 2001, where it still stands today. Its design is geometric, with walls that are both transparent and reflective. Walking the labyrinth's path, visitors can see both their own reflections and, through the reflections, the surrounding environment. The experience is disorienting and leads to a sense of uneasiness, bringing up questions of inclusion and exclusion, private and public spaces.

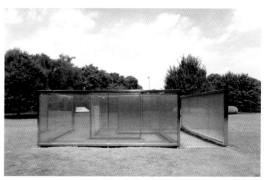

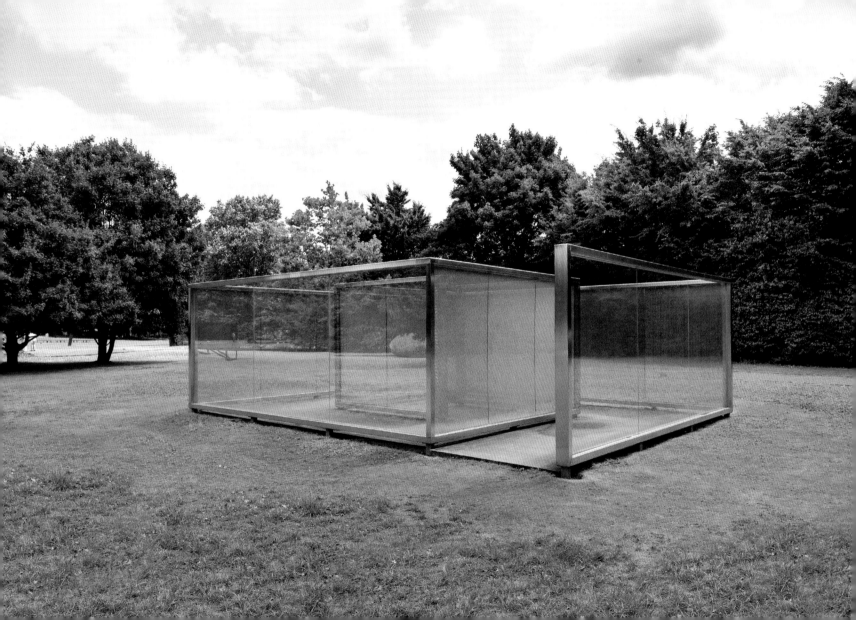

Two-Way Mirror Punched Steel Hedge Labyrinth

- **Designer:** Dan Graham
- **Location:** Minneapolis Sculpture Garden, Walker Art Center, Minneapolis, Minnesota, USA, 1994–96
- **Size:** 7.5 x 17.15 x 42.3 feet (2.28 x 5.23 x 12.9 meters)
- **Material:** stainless steel, glass, and arborvitae

Dan Graham has been examining how spaces influence human behavior since the 1960s. *Two-Way Mirror Punched Steel Hedge Labyrinth* was created for the Minneapolis Sculpture Garden and is one of numerous mirrored and transparent labyrinths the artist has made during the last twenty years. As with *Greek Cross Labyrinth*, the design is geometric and its glass walls are both transparent and reflective. Visitors who walk the labyrinth's path see and are seen at the same time, which generates a sense of discomfort and apprehension in them. Some of the walls are formed by hedges, resulting in a sculpture that changes throughout the seasons.

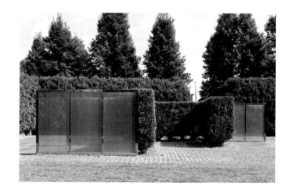

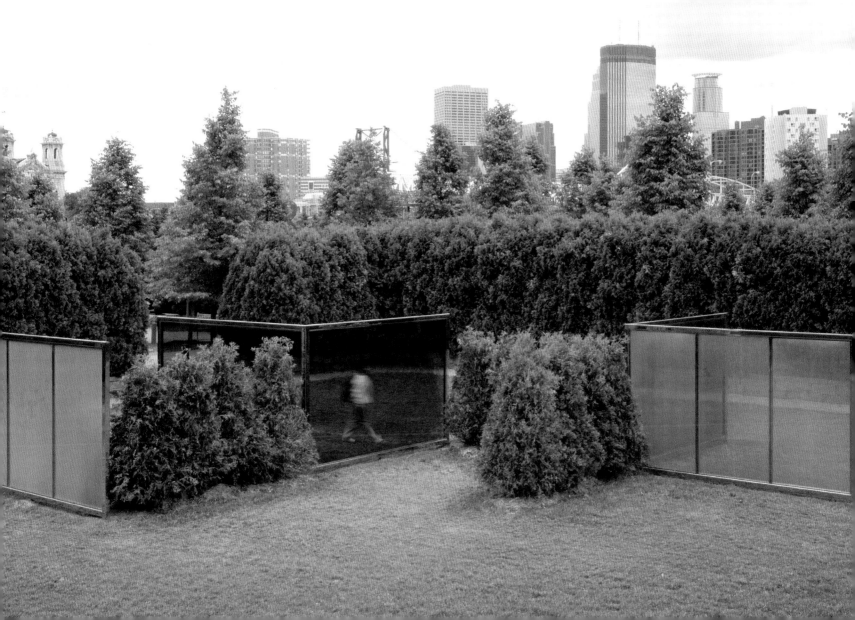

Glass Labyrinth

- **Designer:** Robert Morris
- **Location:** Donald J. Hall Sculpture Park, Nelson-Atkins Museum of Art, Kansas City, Missouri, USA, 2014
- **Size:** 50 x 50 x 50 feet (15.25 x 15.25 x 15.25 meters)
- **Material:** glass panels with bronze rails, sitting on top of a cement-block base

Robert Morris created *Glass Labyrinth* at the invitation of the Nelson-Atkins Museum of Art in Kansas City, where he grew up. Morris has always taken a lively interest in the relationship between works of art and space—both open and closed space—and he addresses those issues with this piece. The triangular labyrinth is meant to be experienced, but because it is transparent, it is not experienced in a vacuum but in relationship to the park and the surrounding natural environment.

The labyrinth is accessed via a small red brick path. Inside the structure is just one path that leads to the center, which, like the perimeter, is in the shape of a triangle.

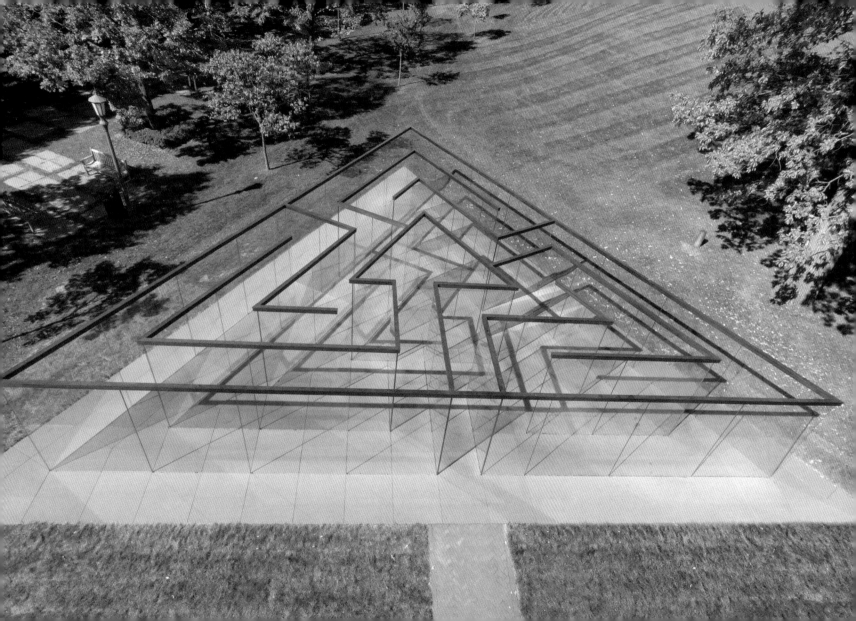

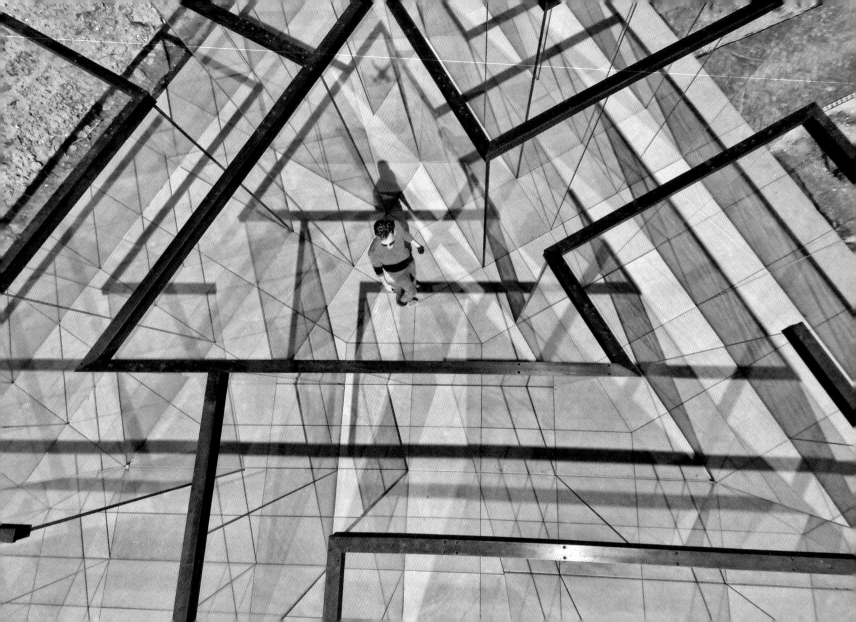

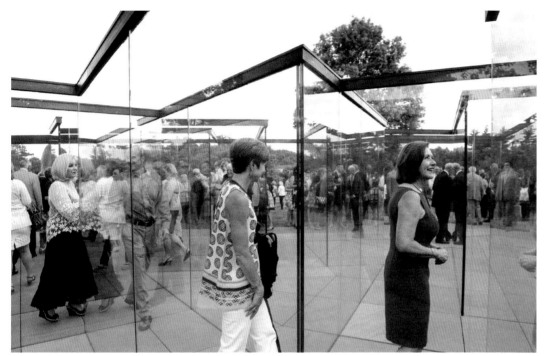

Any labyrinth plays with the idea of getting lost in order to find oneself, but here Morris pushes visitors even further. The transparent walls of the labyrinth become a spatial device that sparks consideration of the relationship between personal history, art, and the nearby natural and manmade elements of the landscape.

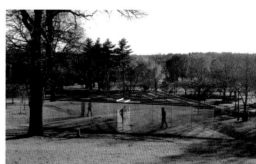

120 Doors Pavilion

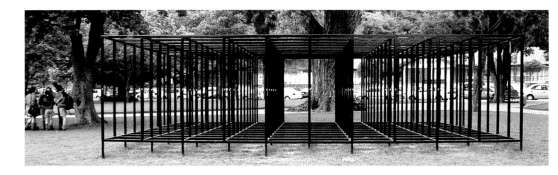

- **Designers:** Mauricio Pezo and Sofía von Ellrichshausen of the art and architecture firm Pezo von Ellrichshausen
- **Location:** Ecuador Park, Concepción, Chile, 2003
- **Material:** wood and steel

This labyrinth, which was created as a temporary installation for a public park in the city of Concepción in southern Chile by the art and architecture firm Pezo von Ellrichshausen, consisted of a single structure made of steel tubes and 120 standard-size wooden doors. The layout was organized around five concentric paths that led to a central room. The doors formed the perimeters, which served as borders and barriers that blocked or at least hindered progress along the path toward the innermost portion of the labyrinth.

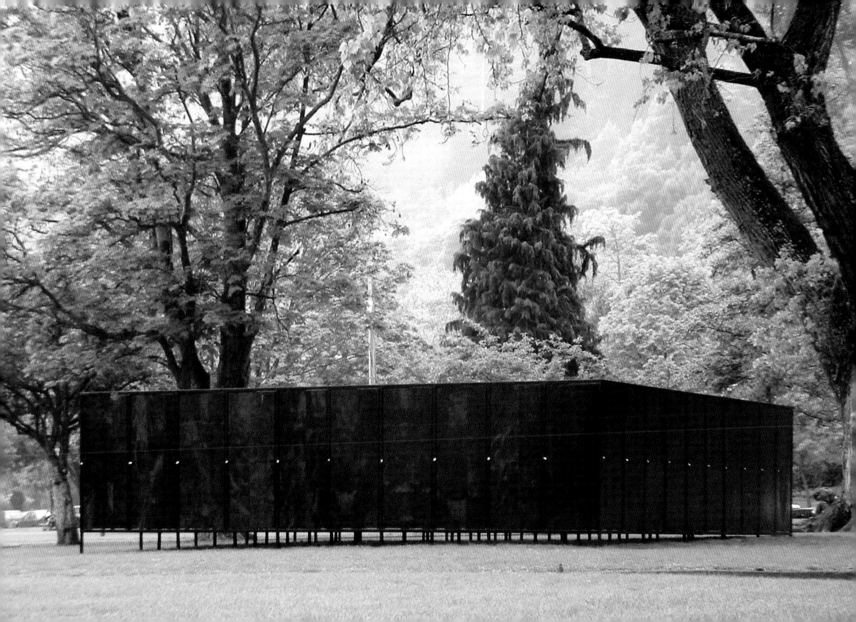

When all the doors on the outermost perimeter were closed, the structure looked like a compact horizontal block. The dark color and hard character of the exterior gave the pavilion the look of a mysterious fortress, fostering curiosity about what might be inside. The adventure began when people opened a door to undertake the journey into the interior and then back out again through a maze of possible paths. The paths were rather narrow, essentially tall hallways that intentionally made visitors feel constricted and urged them on.

The innermost room of the labyrinth was a cube contained within the structure's smallest perimeter. After having walked along winding narrow pathways, visitors arrived at the center to experience a contradictory sensation: on the one hand, they were relieved at having reached their goal, on the other hand, they felt more constrained than ever in this small, closed space. The only solution was to walk the labyrinth in reverse to return to the exit and get back in touch with the outside world.

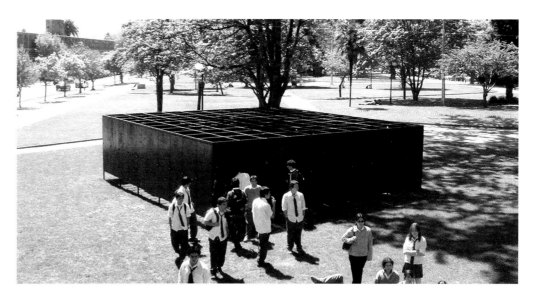

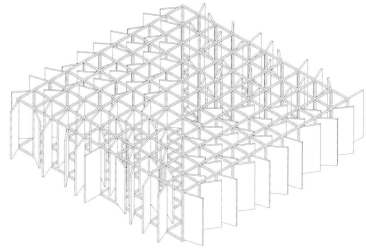

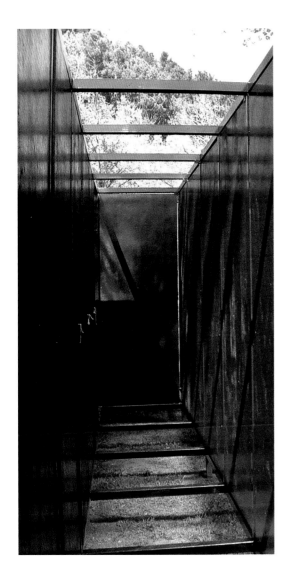

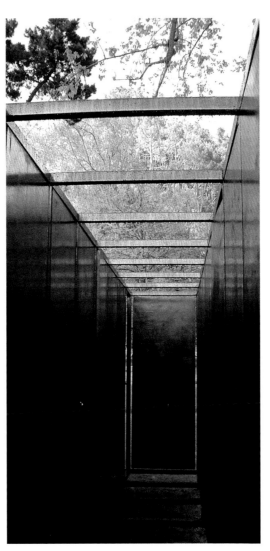

The installation also included some dead ends with fixed panels to disorient visitors and force them to seek new routes. The combination of tall walls and narrow pathways inspired a certain sense of dread in people walking through the maze, but the opening doors and the ability to see the sky and the ground throughout counterbalanced this sense of unease.

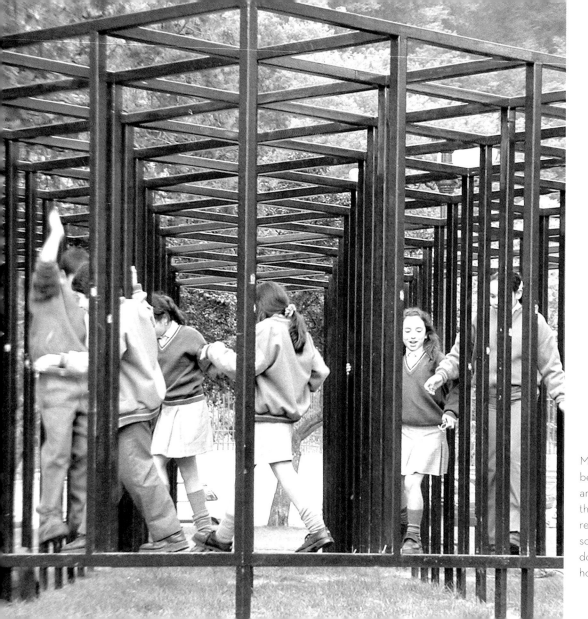

Mauricio Pezo and Sofia von Ellrichshausen have long been interested in the relationship between art and architecture. With *120 Doors Pavilion* they illustrated that the distinctions between the two are in reality relative and artificial. After being on display for some time, the installation was dismantled, and the doors were donated to the Ecuadorian public housing authority.

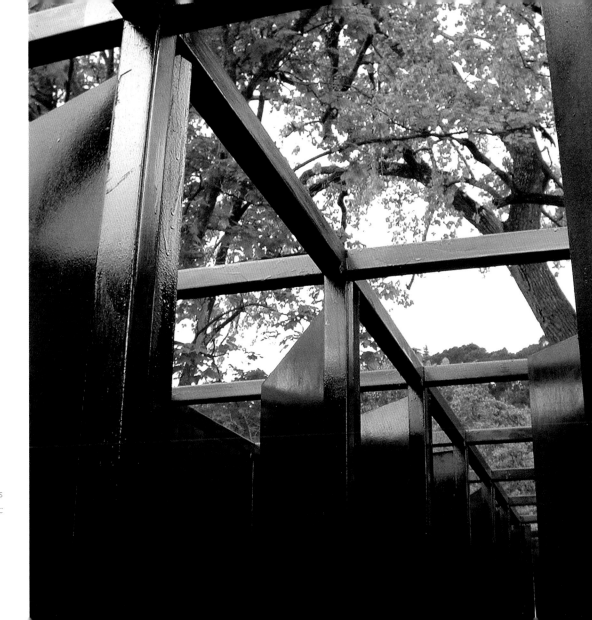

"We think of the doors as a turning point that subverts temporally the definition of space, adding a dynamic dimension to the construction of walls in a work of architecture, something that could be seen as a key that regulates the fluctuation of forces."
—Mauricio Pezo and Sofía von Ellrichshausen

The Big Maze

- **Designer:** BIG | Bjarke Ingels Group, architects
- **Location:** National Building Museum, Washington, DC, USA, 2014
- **Size:** 60 x 60 feet (18 x 18 meters)
- **Material:** maple plywood

This temporary installation at the National Building Museum was created by the Copenhagen- and New York–based architecture firm BIG. The structure, whose overall design was inspired by the pattern of typical Renaissance mazes, was made of maple plywood walls, which were approximately 18 feet (5.4 meters) high at the external corners but grew shorter toward the center of the maze.

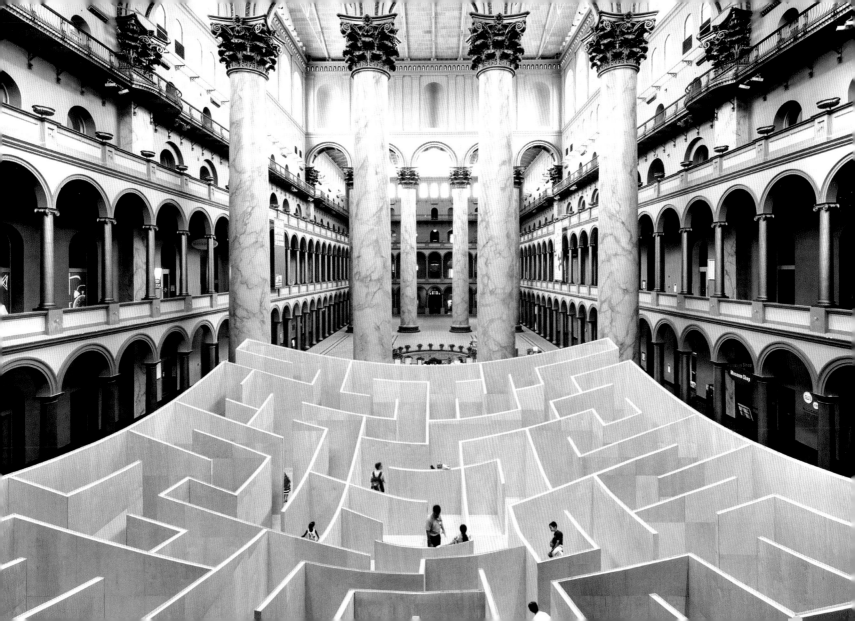

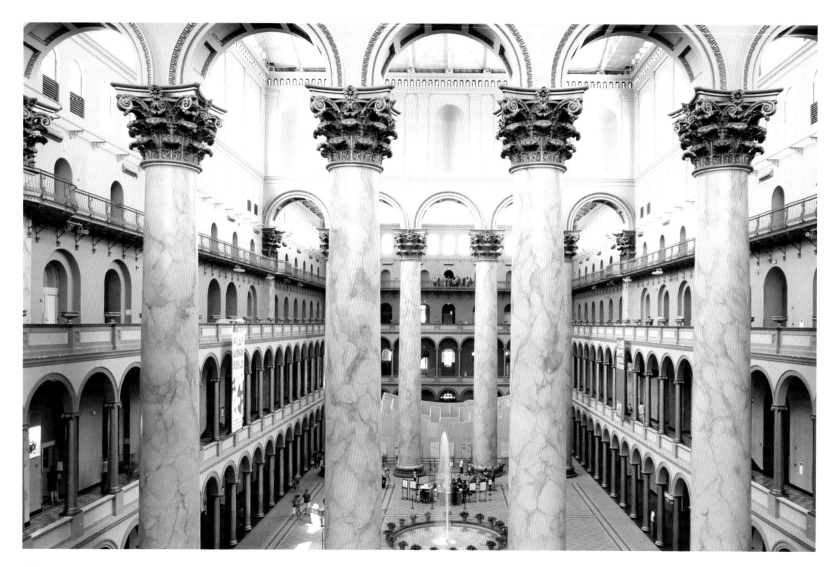

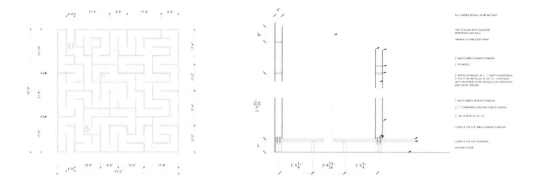

Bjarke Ingels and his studio started from a very simple idea: typically, the closer one gets to the center of a traditional maze, the more its path twists and turns and the more difficult it gets to find one's way. For *The Big Maze*, the designers inverted the classic scheme, creating a maze whose path got simpler toward the center, because the decreasing height of the walls made it easier to view its twists and turns. That did not diminish the fun and suspense involved, especially for children, who experienced the maze as pure entertainment and a delightful adventure.

Adults, however, seemed to experience a primordial fear of getting lost in the maze, which spurred many visitors to go up to the mezzanine level of the museum atrium first, in order to view the maze from above and memorize its layout and especially the location of its exits before daring to enter it.

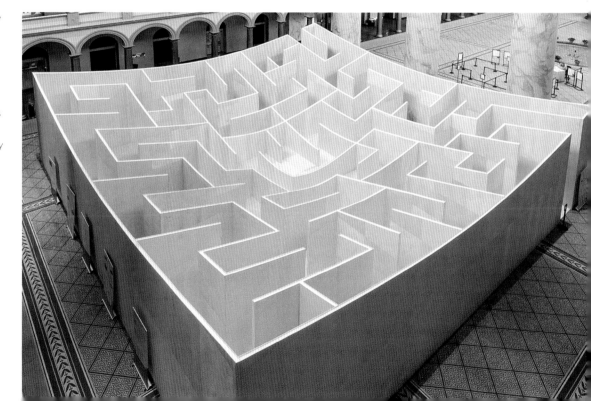

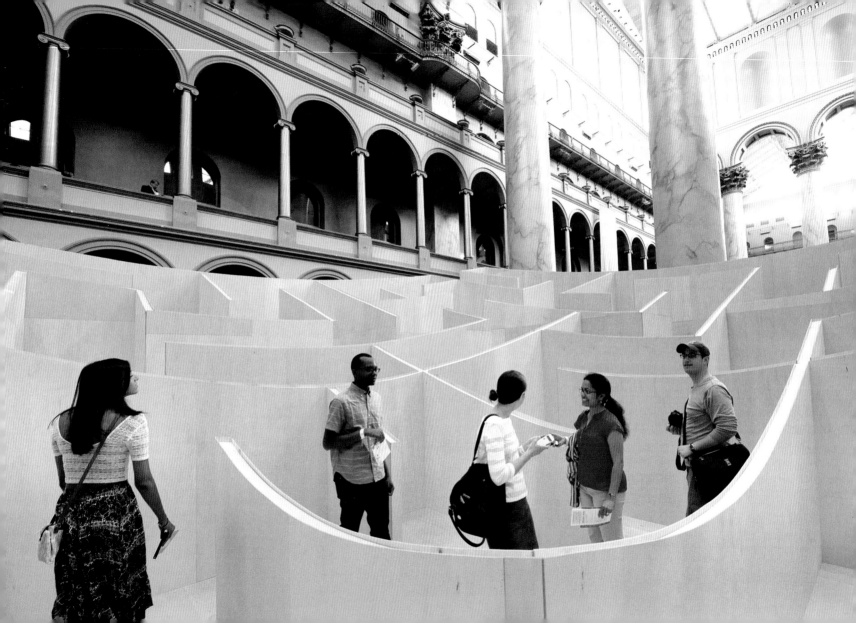

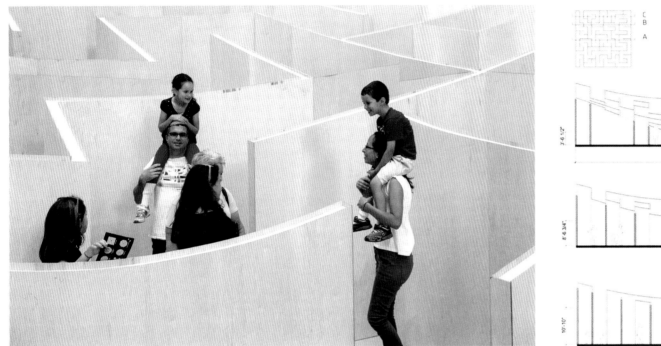

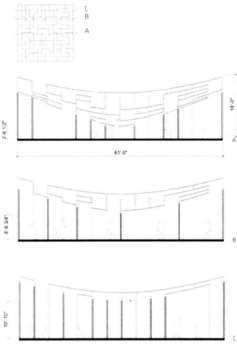

This feeling of unease vanished in the center of the maze. Here everything was legible, clear, and calm, and there could be no doubt about which path to follow.

Wood Interior

- **Designer:** Richard Fleischner
- **Location:** Artpark, Lewiston, New York, USA, 1976
- **Size:** 12 x 29 x 29 feet (3.6 x 8.8 x 8.8 meters)
- **Material:** Norway spruce, western hemlock, and pine wood

This labyrinth was a temporary installation at Artpark in upstate New York and a signature piece of Richard Fleischner's *Fields* series. It combined the idea of an interior with the concept of the surface. The multiple relationships that can be established between fields/planes and vertical surfaces generate different types of space, here including narrow and restrictive spaces, pathways, and large chambers that were effectively voids—empty and inaccessible fields bordered by vertical surfaces.

Wood Interior was a compact wooden structure that was closed off from the outside. Besides the entry/exit point it had no openings to the surrounding countryside. A single path led from the exterior to a central space, just like in a traditional labyrinth. In this case, however, the path brushed up against the central space but did not actually offer access to it. The artist thus emphasized the concept of the void, not only in terms of space but in the spiritual sense as well, hinting at the fact that when you seek something, there is no guarantee that you will find it, and the experience may be a disturbing or unfulfilled one.

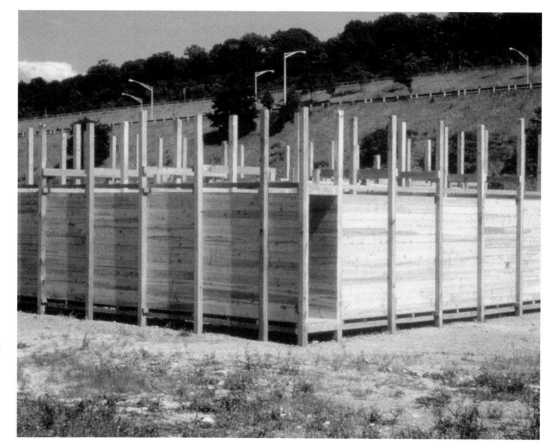

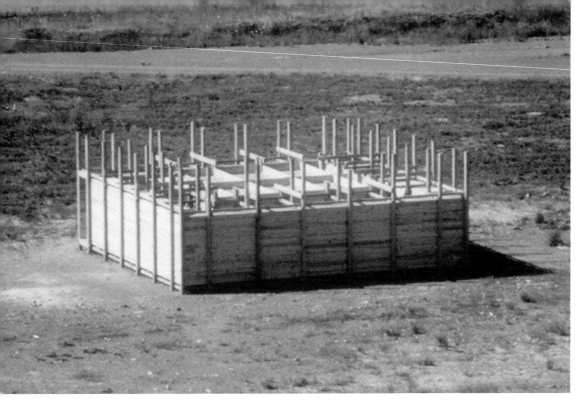

From the outside, *Wood Interior* appeared to be
a pure volume, a rectangular box whose profile stood
out against the landscape, with the pine wood used
to build it contrasting with its setting in a grassy open
space. The entrance was obvious and an explicit
invitation to enter this mysterious work of architecture.

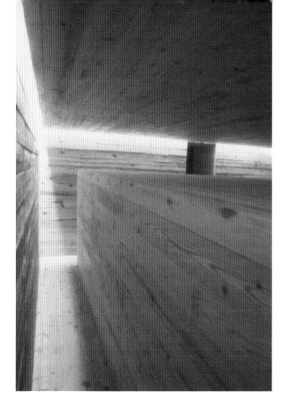

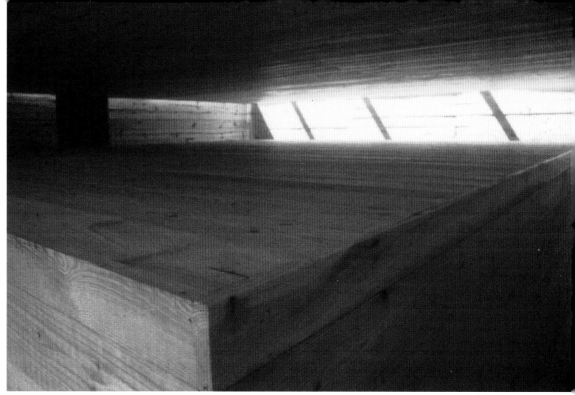

Inside the labyrinth, visitors followed a narrow hallway to arrive in a large chamber containing the inaccessible central space. The path did not open up into any other rooms, but did afford glimpses of them. Traveling through this labyrinth was more about the journey than about reaching the destination.

Hay Maze

- **Designer:** Richard Fleischner
- **Location:** Rehoboth, Massachusetts, USA, 1971
- **Size:** 4.5 x 15.3 x 17 feet (1.4 x 4.6 x 5 meters)
- **Material:** baled hay, with an interior structure made of wood

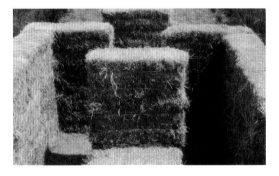

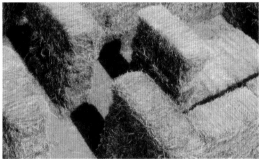

This small temporary installation by Richard Fleischner took its cues from a deeply rooted cultural tradition. American farmers have long created mazes out of hay bales during the harvest season, and at summer and fall fairs, adults and children love to navigate them. *Hay Maze* was part of the artist's *Fields* series, which took as its starting point the field in its most essential shape—a square or a rectangle—and played with a variety of simple methods for establishing interior and exterior spaces.

With *Hay Maze*, Fleischner outlined a space that inspired people to contemplate both the inside and the outside. Visitors could sit in this small room open to the sky and look inward or outward, or they could move about the maze, experiencing the interior without losing sight of the surrounding countryside. Various views of *Hay Maze* (above and opposite) capture the ambivalence of a space that can be experienced in isolation or in dialogue with the surrounding countryside.

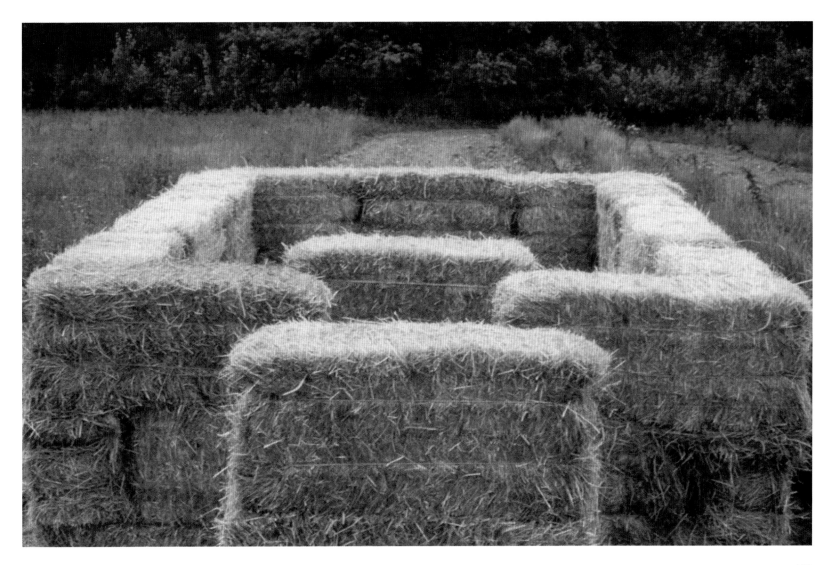

Tufa Maze

- **Designer:** Richard Fleischner
- **Location:** Rockefeller Collection, Pocantico Hills, New York, USA, 1973
- **Size:** 4.5 x 15.3 x 17 feet (1.4 x 4.6 x 5 meters)
- **Material:** large blocks of moss-covered tufa stone

Tufa Maze, built by Richard Fleischner in the shade of a tree in Pocantico Hills, New York, explores the relationship between the concept of a small enclosed space, such as the Etruscan tombs the artist had visited in Cerveteri, Italy, which inspired this piece, and the cell of a primitive labyrinth. The moss-covered tufa stone blocks used to build the maze had been discovered by Fleischner during a trip to the Italian town of Civita Castellana. They lend the maze an oppressive atmosphere, but for Fleischner it acts as a shelter, a refuge, a stable architectural structure. In the center is a tufa stone seat facing a raised slab. The entire piece recalls the solemnity of a tombstone, although the organization of the stone blocks references a basic labyrinth design.

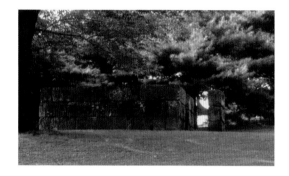

Misaligning some of the stone walls with each other, the artist created a simple labyrinth composition. Fleischner first planned the piece using models in his studio, where he investigated how to arrange the blocks in a similar way a child would use building blocks.

The first building block toys were invented by nineteenth-century German pedagogue Friedrich Froebel, who wanted to help children discover themselves through play. To stimulate this process, he invented what are known as the Froebel Gifts, a set of small blocks in different shapes that can be used to build various objects. A child uses the blocks to build a house, a city, or a person, and then names the object to give it an identity. Fleischner worked in a similar way to build this piece, which he then called a maze. He was not the only artist working on this concept in the 1970s; land artists Donald Judd and David Smith, to name just a few of his better-known peers, were interested in the same idea.

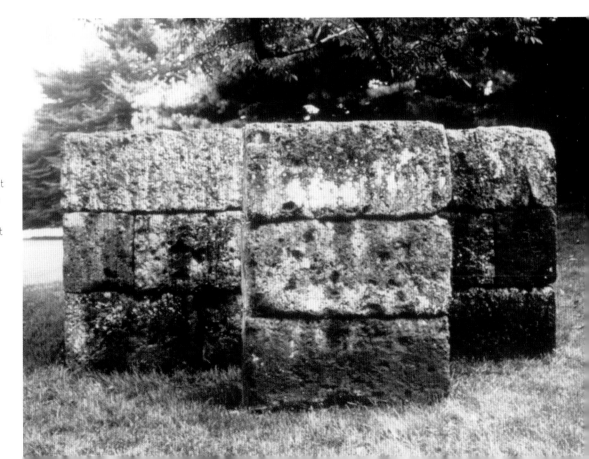

Minotaur

- **Designers:** Nick Coombe and Shona Kitchen
- **Location:** Kielder Water and Forest Park, Kielder Castle, Northumberland, UK, 2003
- **Size:** 72.2 x 59 feet (22 x 18 meters)
- **Material:** metal wire cages with basalt; recycled glass

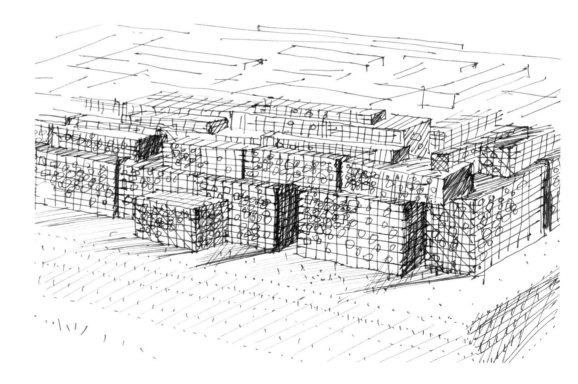

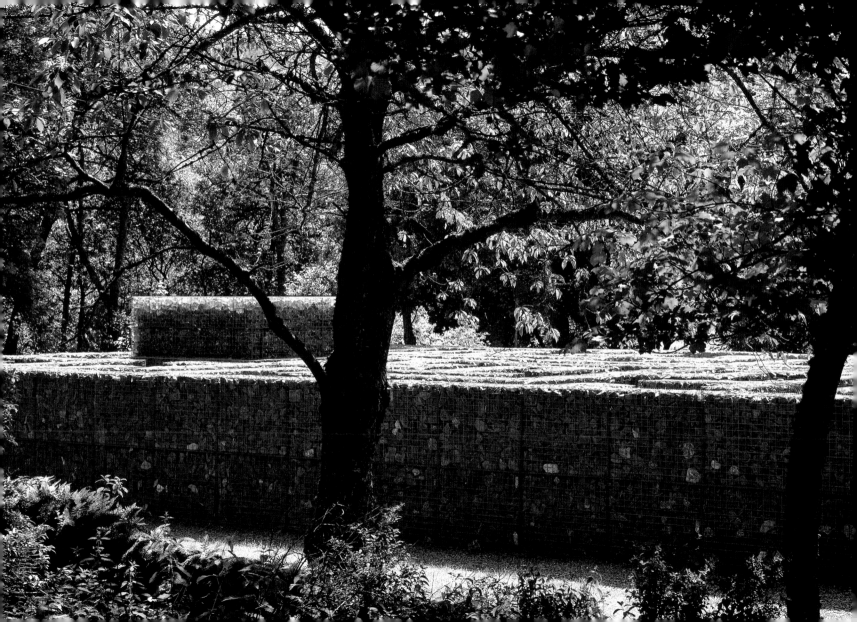

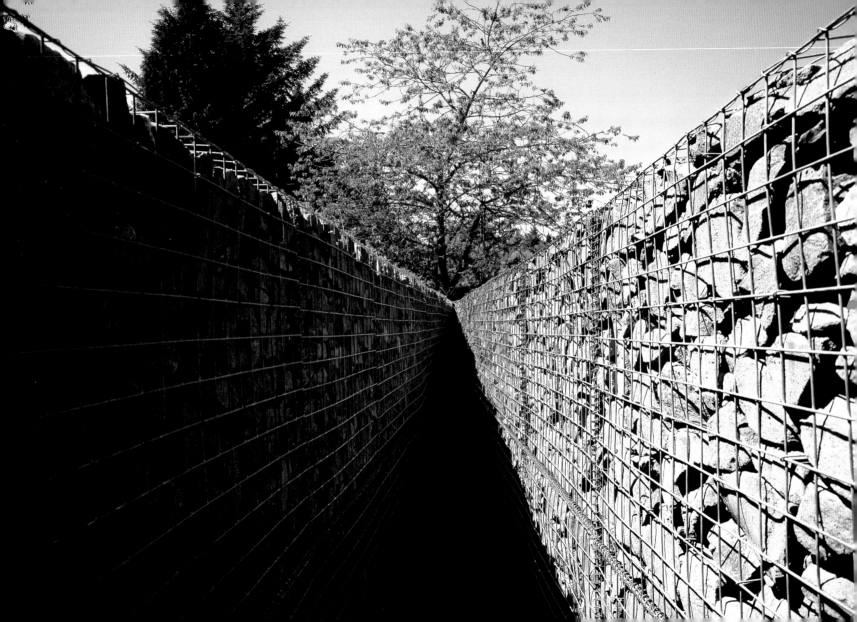

Minotaur is part of the Kielder Water and Forest Park, a park on the grounds of Kielder Castle in Northumberland and an exhibition venue for various pieces of art and architecture. The project is a classic maze—inspired by the Knossos maze in Crete—whose path leads to an upper central room that allows a full view of the surrounding countryside and of the entire maze itself. The walls of this unusual room, basically a small lookout tower, are made of recycled turquoise glass. It stands above the rest of the maze so that visitors traveling the maze can keep their eyes on their destination.

Minotaur has a classic multicursal layout, but it includes some unusual elements, such as a meditation room. One dead end contains a small hiding place, where children can wait to surprise their parents. In 2010 the piece was part of the *Per Laberints* exhibition taking place in Barcelona, Spain.

Labirinto di Arianna

- **Designer:** Italo Lanfredini
- **Location:** Fiumara d'Arte sculpture park, Castel di Lucio, province of Messina, Italy, 1989
- **Material:** concrete

Fiumara d'Arte is an outdoor sculpture park in the Sicilian countryside near Messina. It was founded by Sicilian patron of the arts Antonio Presti, who wanted to bring life back to an area deeply damaged by the Mafia. Presti invited artists from all over the world to create works conceived specifically for this little-known corner of the Nebrodi mountains along the Tusa riverbed. One of the most interesting sculptures is Italo Lanfredini's *Labirinto di Arianna* (Ariadne's Labyrinth), built on a hill near Castel di Lucio. The labyrinth is a gigantic circular cement structure with a pointed arch rising out of it.

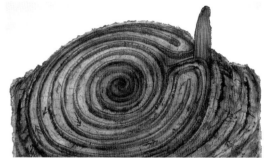

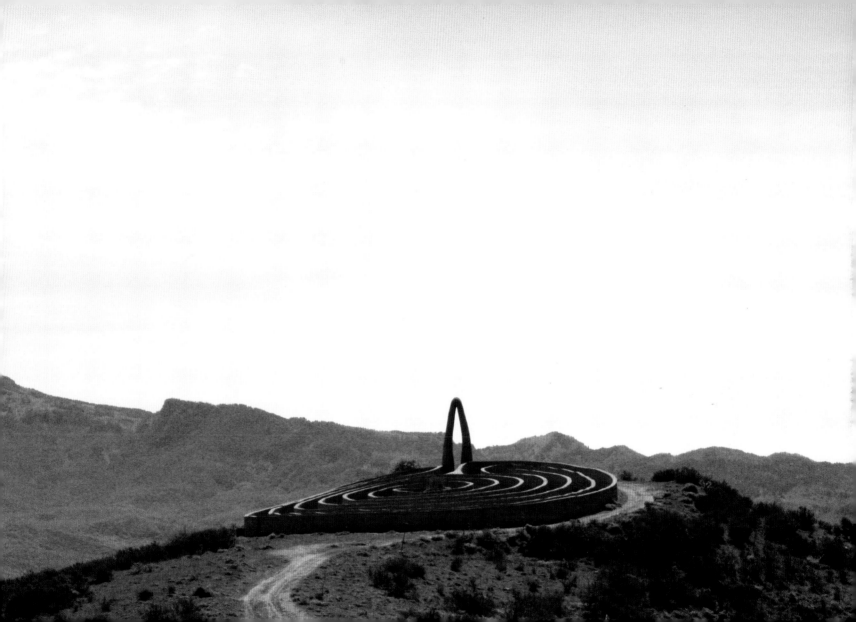

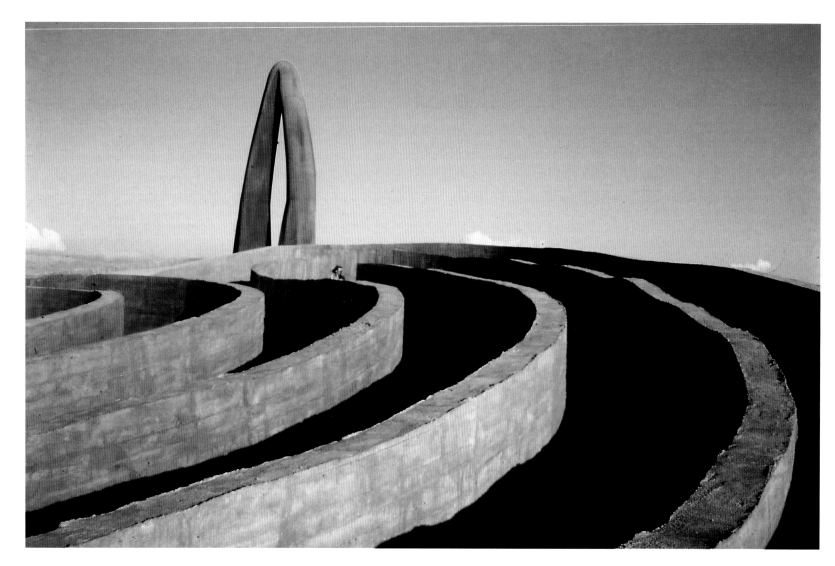

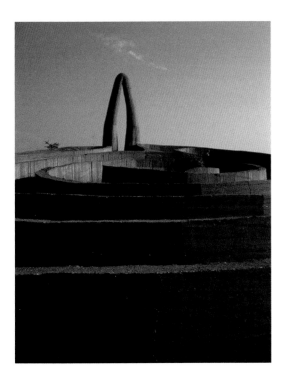

For this massive architectural project, Lanfredini returned to the primitive form of a spiral—a shape that clearly echoes the classical age and the Knossos labyrinth. Despite these ancient roots—or perhaps because of them—the artist used the material that most strongly symbolizes the modern age: concrete. This gives the symbolic archetype a thoroughly modern flavor and creates an interesting contrast. The walls are made of raw concrete and are almost 6.5 feet (2 meters) high, clinging to the slope of the hill while spiraling inward toward a tree at the center. The labyrinth itself is therefore on an incline, and while traveling through it, visitors are always moving either up or down. This allows them to maintain contact with the surrounding landscape as they glimpse it from time to time.

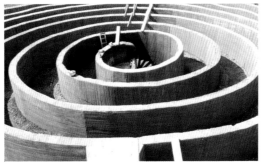

Philadelphia Labyrinth

- **Designer:** Robert Morris
- **Location:** Institute of Contemporary Art, University of Pennsylvania, Philadelphia, Pennsylvania, USA, 1974
- **Size:** 29.5 feet (9 meters) in diameter
- **Material:** masonite

This labyrinth was created by the artist especially for the exhibition *Robert Morris/Projects*, which was held at the University of Pennsylvania's Institute of Contemporary Art in the spring of 1974. "Enter at your own risk. Persons with claustrophobia or delicate health are not advised to walk through the labyrinth," the curator warned the public at the time of its opening. Those who did dare approach found themselves facing a massive structure. The smooth gray circular outer wall was solid and impenetrable with the exception of a vertical crack only 17.7 inches (45 centimeters) wide that allowed access to the single path that led to the center. The walls were almost 10 feet (3 meters) high. It only took about three minutes to travel the labyrinth, but during those three minutes, visitors felt the oppressive quality of the space. This work explored a series of signature Morris concepts—which often take the form of seemingly contradictory pairs—including mind/body, theory/experience, facts/perception, hidden/exposed, stasis/transformation, and artwork/viewer.

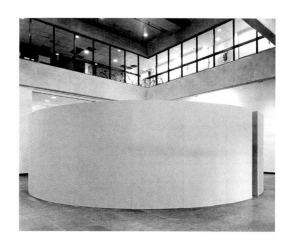

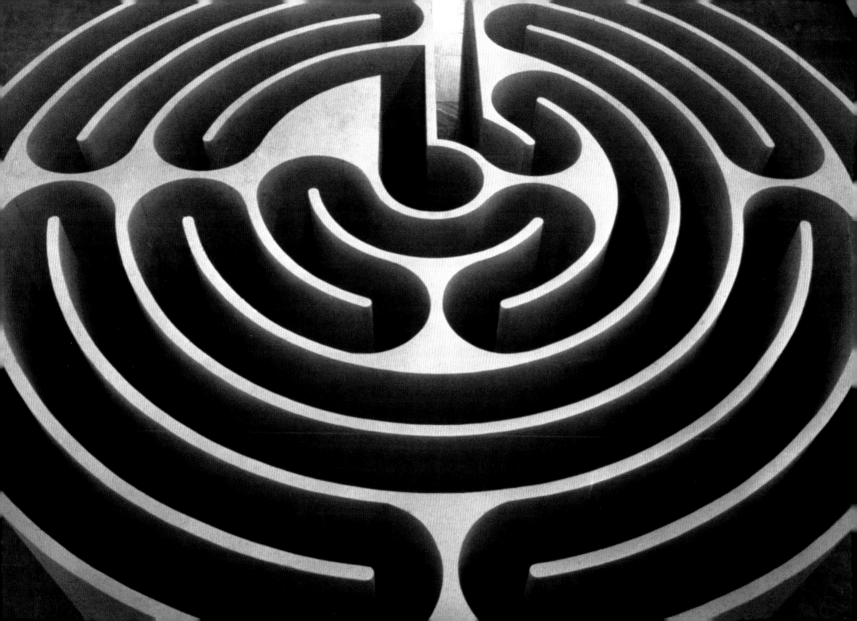

Coming Full Circle

- **Designer:** Chris Drury
- **Location:** Stacksteads Community Woodland, Lancashire, UK, 1999
- **Size:** 52.5 feet (16 meters) in diameter
- **Material:** stone

This work by British land artist Chris Drury looks like a giant mill's waterwheel made of stone and placed on its side. Created using a dry stone-wall technique, the labyrinth offers five potential paths that lead to the middle, where an oak tree has been planted. Plant life takes center stage in this project. Hawthorn, apple, and cherry trees have been planted around the labyrinth; once grown, their blossoms in spring will look like foamy water churning around the waterwheel.

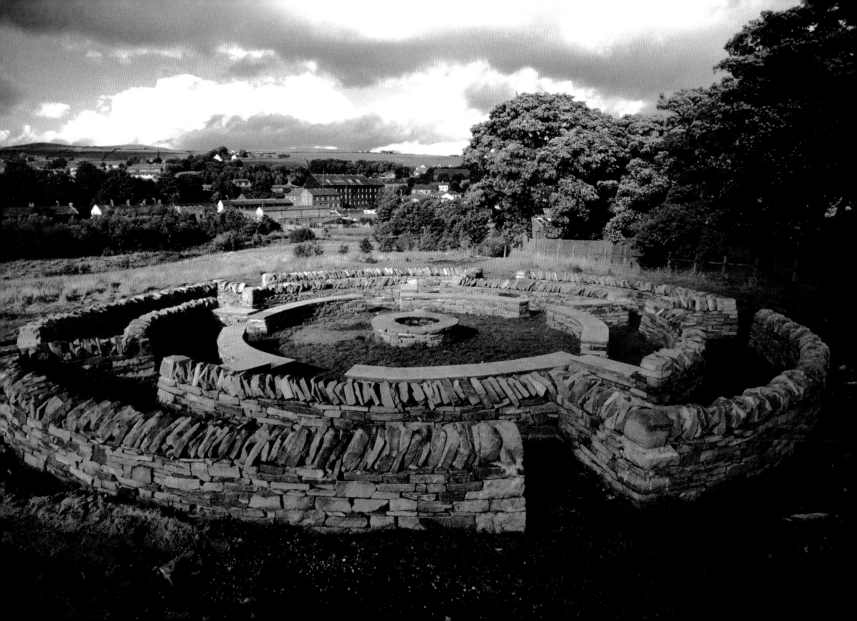

Labyrinthe

- **Designer:** Marta Pan
- **Location:** Lycée de Madame de Stael, Montluçon, France, 1973
- **Material:** enameled concrete panels

The Hungarian-born artist Marta Pan created this labyrinth for a high school in Montluçon, France, with the aim to inspire young people to make their own decisions in the key transition to adulthood. According to Pan, she chose the labyrinth as a symbol of maturity because it invites people to take responsibility for their choices; it encourages them not to be afraid of what they do not know or of making mistakes.

At the unveiling of *Labyrinthe*, students, teachers, and many officials, including the prefect of the region, helped put into place the small hexagonal panels that cover the concrete structure. The creation of this kind of mosaic was heavily symbolic, representing rebirth and endless possibility—emphasizing that one can start again after making a mistake, an important message for all.

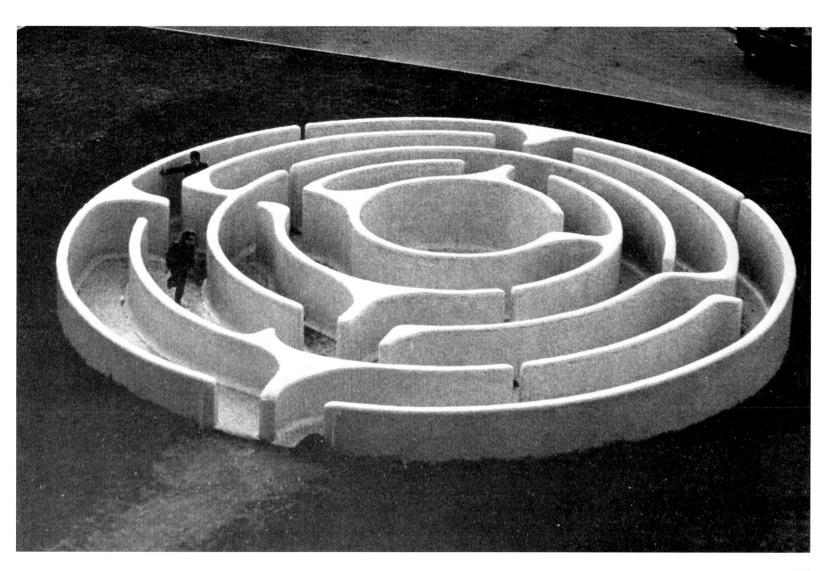

Armand Erpf Maze

- **Designer:** Michael Ayrton
- **Location:** Catskill, New York, USA, 1968–69
- **Material:** whitewashed brick (walls) and stone (path)

British artist and writer Michael Ayrton (1921–1975) was fascinated by mazes and the myth of Daedalus and created a variety of sculptures, illustrations, poems, and stories based on mythical content. The Catskill maze, made for the banker Armand G. Erpf, is Ayrton's highly personalized idea of the labyrinth Daedalus built for King Minos of Crete. In the center of the structure, whose path covers 1,678 feet (512 meters), Ayrton located two "rooms": one containing a statue of the Minotaur, and the other a statue of Daedalus. The artist identified with both and gave the Minotaur human arms, hands, legs, and feet, alluding to the dual tragedy of the Minotaur, which was trapped both in its own body and within the walls of the maze.

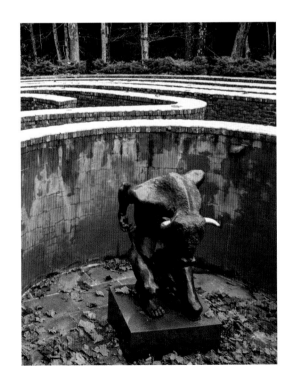

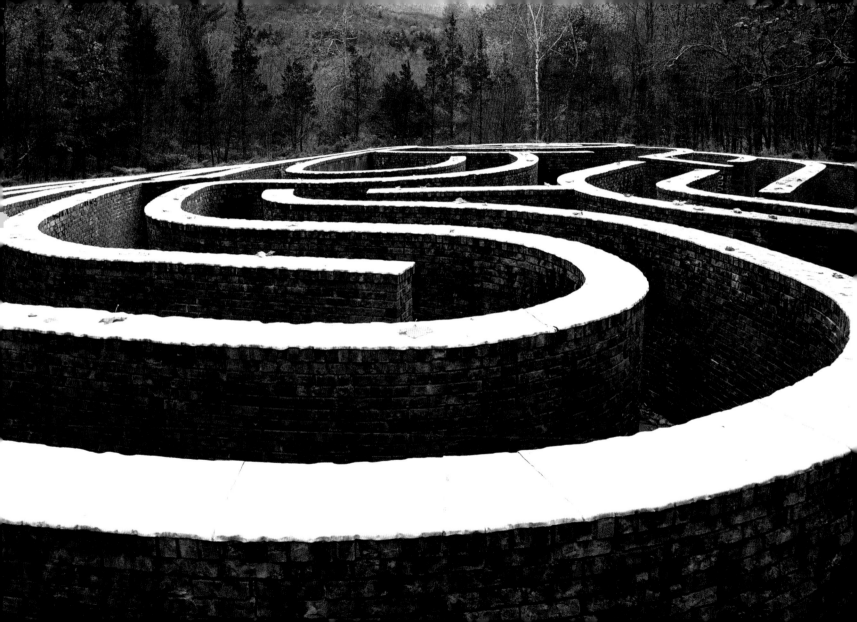

Wanhua Zhen Maze

- **Designer:** Giuseppe Castiglione
- **Location:** Summer Palace, Beijing, China, 1756–59, rebuilt 1977–92
- **Size:** 292 x 193.5 feet (89 x 59 meters)
- **Material:** stone

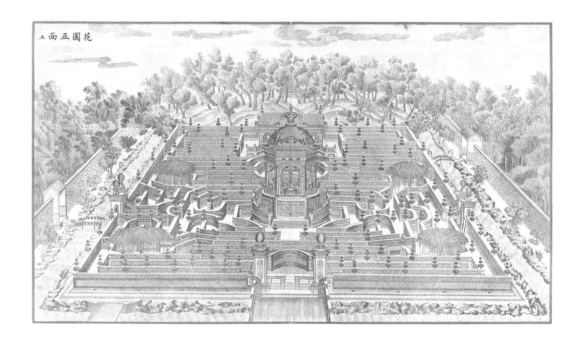

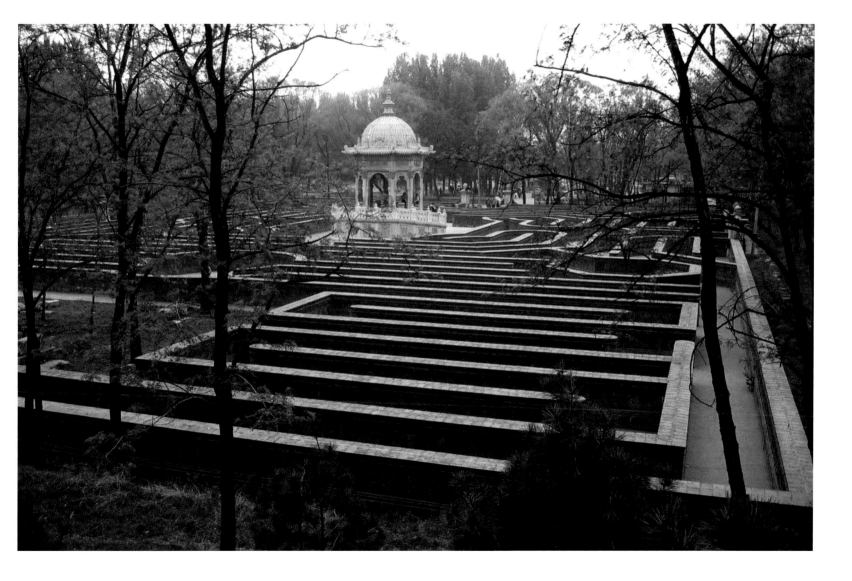

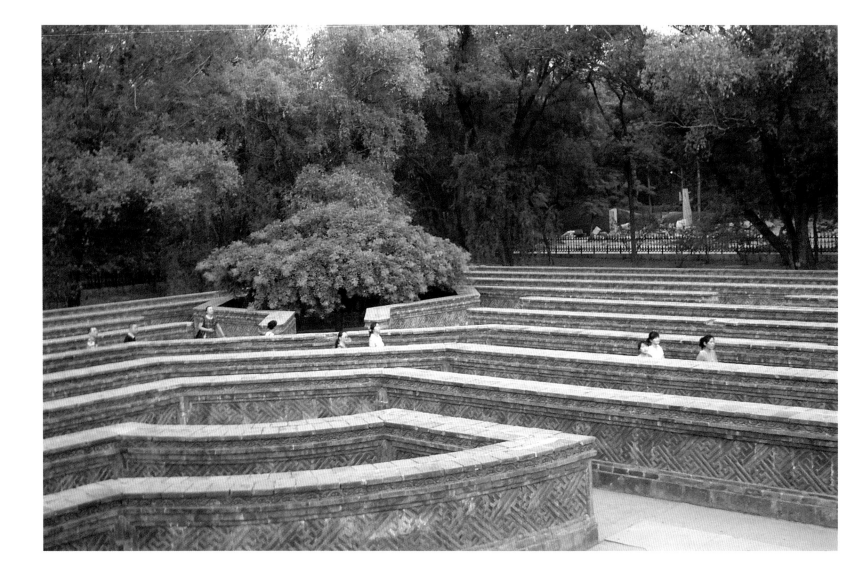

Wanhua Zhen, literally "the maze of 10,000 flowers," also known as *Huanghuazhen*, the "yellow flower maze," was commissioned by Emperor Qianlong, who wanted a European-style garden for the Old Summer Palace, located outside the Forbidden City. Creation of the gardens began in 1747 and continued a year later with the addition of water features. The maze was built a few years later, and in 1783 the Yuanying Guan observatory was added. The Old Summer Palace and the rest of the complex caught fire during an attack by Anglo-French forces during the Second Opium War in 1860. The entire architectural structure and its gardens, including the maze, were rebuilt between 1977 and 1992.

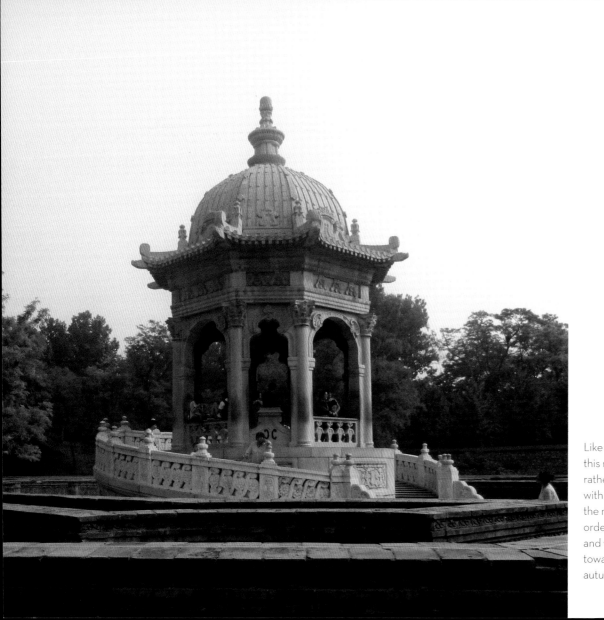

Like many of its Renaissance counterparts in the West, this maze, though made of stone blocks with bas-reliefs rather than hedges, has a circular pavilion in the center with a viewing platform that allows visitors to see the maze from above. Legend has it that the emperor ordered this pavilion built so he could sit in it and watch concubines racing through the maze toward him, holding yellow lanterns, during the mid-autumn festival.

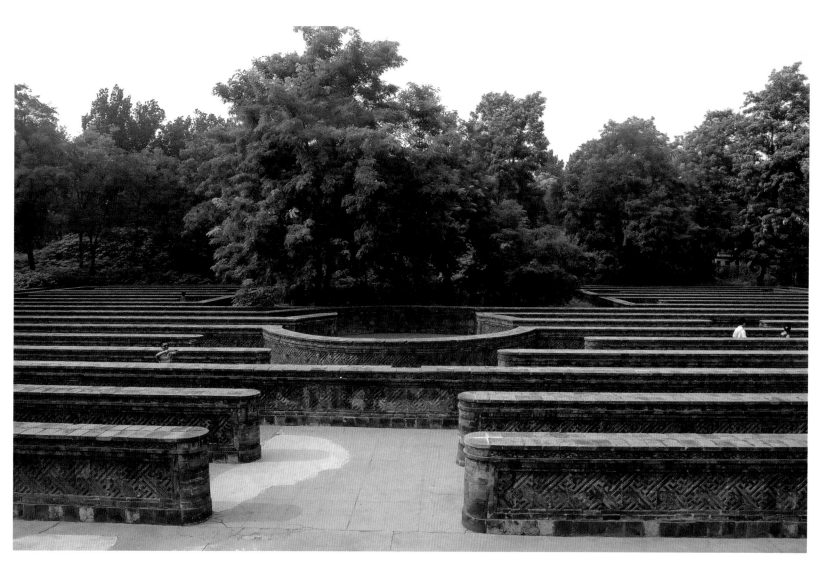

Labyrinth

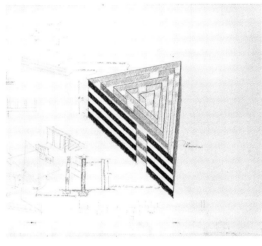

- **Designer:** Robert Morris
- **Location:** Fattoria di Celle, Santomato, province of Pistoia, Italy, 1982
- **Size:** 49.2 x 49.2 x 49.2 feet (15 x 15 x 15 meters)
- **Material:** Trani marble, serpentine marble, and concrete

The labyrinth is one of Robert Morris's main subjects. The artist interprets it as a symbol of individual maturation and the action of following it as a basic part of the pilgrimage that allows man to reach his own center. Penetrating it therefore becomes an initiation rite. The center is the start and the end of all things. At the basis of Morris's work are the essential humanist principle of the centrality of man and the question of how it can coexist with the concept of the void—the absence of meaning, as well as the relationship between the self and the body; the latter becomes a bridge from the inner world of the human soul to the outer world of space and the environment. In this sense, the labyrinth takes on new meaning by reflecting systems of oppression of the body through standardization.

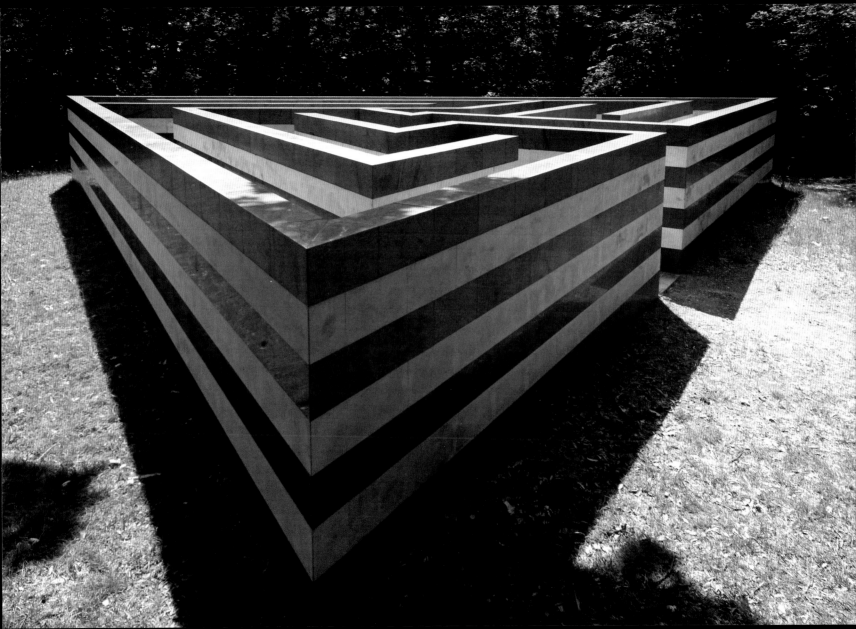

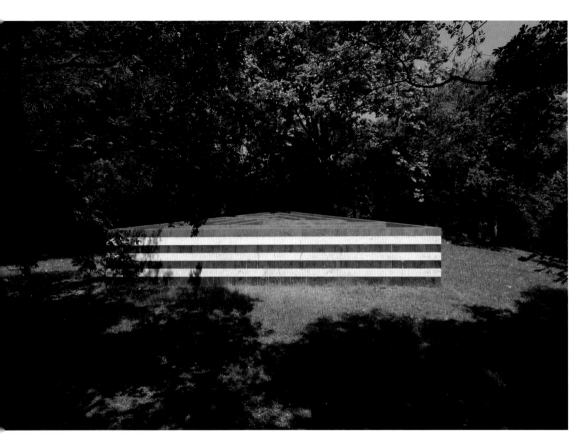

This labyrinth is a triangular structure that fits harmoniously into the natural context of the park. Describing it, Morris said, "You go around and around endlessly, looking for a center that continues to escape you. Seeking with or without a thread threatens a collapse, slippage, getting lost at every turn. Each passage: a strategy, a calculation, a measure, an abandonment, a recovery, a reinitiation."

Labyrinth is part of the Fattoria di Celle (Celle Farm) in the province of Pistoia, Italy, which hosts the art collection of Tuscan collector Giuliano Gori. Gori opened the seventeenth-century countryside mansion and its gardens to the public in 1982, exhibiting installations by a range of international artists.

The labyrinth, which looks like a rectangular structure at first glance, stands in the middle of a small lawn on an incline, surrounded by dense woods. It has tall walls and a narrow entry that leads to a single path, which winds downhill first and then climbs up the hill. Only one person at a time may enter. Inside, visitors follow a long, narrow hallway that ultimately ends in a solid wall, a dead end, forcing them to retrace their steps back to the entry.

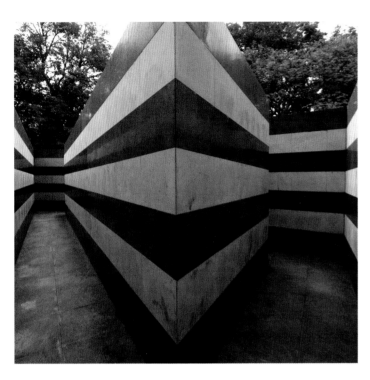

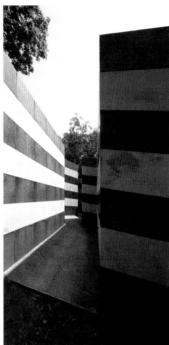

A raised platform located nearby and hidden from view by trees reveals that the labyrinth is in fact not a square but an equilateral triangle and that its starting and end points are adjacent to each other, separated only by a wall. The theme of this work is journey, both in the physical sense (go out and learn about the world) and in the psychological sense (look for oneself). In both cases, there are critical moments and sharp corners, as well as easier times when it seems as if one is rolling downhill. These alternating states form a large part of human existence, symbolized here by the labyrinth's twisting path. While we can make choices in life, ultimately we can follow only one path.

The structure's green-and-white striped walls clearly reference Romanesque Tuscan churches, but this choice was neither purely aesthetic nor simply an homage to traditional architecture. The artist reinterpreted the two-tone historical Italian tradition in a wholly original way in order to increase the labyrinth's power of dizzying disorientation through the rhythm of the alternating light and dark bands on the walls of the narrow passageway.

Chain Link Maze

- **Designer:** Richard Fleischner
- **Location:** University of Massachusetts, Amherst, Massachusetts, USA, 1978–79
- **Size:** 8 x 61 x 61 feet (2.45 x 18.6 x 18.6 meters)
- **Material:** chain-link fencing

The *Chain Link Maze* installation at the University of Massachusetts was part of a series of works by Richard Fleischner titled *Surface*. Located in a field bordered by woods, the maze was perfectly square, with a traditional grass path but with walls that consisted of a thoroughly modern material: chain-link fencing. The maze had a single entrance and a central space, but once visitors entered, they had to choose from among various routes, several of which were dead ends.

Fleischner was working on two levels here: on the one hand, he used a layout that clearly belongs to the school of Renaissance mazes, which were intended for fun and entertainment, and on the other hand, his chosen material communicated a sense of constriction, recalling prison yards.

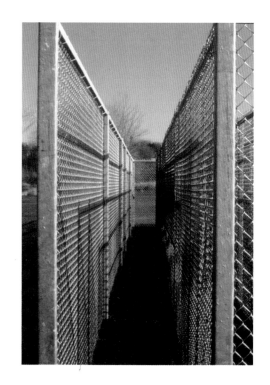

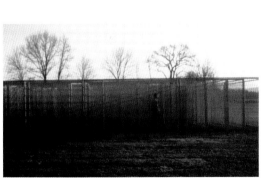

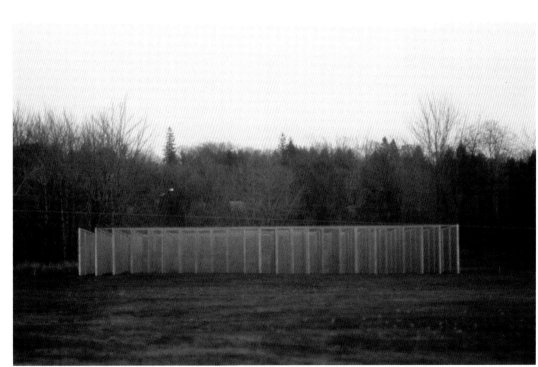

At first sight, the fencing appeared ethereal and evanescent, but as visitors moved toward the center, their view of the surroundings became limited by the multiple layers of chain link. Visibility progressively deteriorated, until it became almost obliterated from the vantage point of the central room.

With this project, Fleischner began to develop another of his favorite themes, moving beyond the concept of horizontal and vertical planes to the question of an artwork's alienation from its surroundings. In this case, visitors of the maze gradually lost sight of the environment as they approached the heart of the piece.

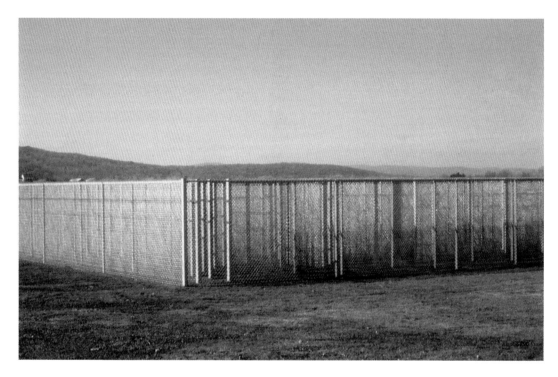

Chain Link Maze was a clear reference to prisons and deliberately generated discomfort and disorientation. It was also a play on contrasts, including that between the concept of a Renaissance-style maze, created for pure entertainment, and the use of prison-style tall chain-link fencing to block off the paths. The gaps in the fencing made it seem transparent, but from deeper inside the maze, the multiple layers of chain link made the outside world fade from view.

Labyrinth

- **Designer:** Gijs Van Vaerenbergh with Bollinger + Grohmann (structural engineer)
- **Location:** C-mine art center, Genk, Belgium, 2015
- **Size:** 123 x 123 feet (37.5 x 37.5 meters)
- **Material:** steel

In the square in front of the entrance to the C-mine art center in Genk stands a large steel maze created by Pieterjan Gijs and Arnout Van Vaerenbergh of the architecture and art studio Gijs Van Vaerenbergh and commissioned by the center to celebrate its tenth anniversary. The large-scale steel structure, which boasts walls that are 16.4 feet (5 meters) tall, contrasts with the old industrial brick building of the former coalmine complex. It is designed as a rectangular grid from which simple solid shapes—a sphere, a cylinder, and a cone—have been carved out, resulting in a dynamic and varied composition. As seen in the image pictured on the bottom right, portions of the perimeter walls of the maze have been cut out as if hit by a sphere, opening the maze toward the museum and its visitors.

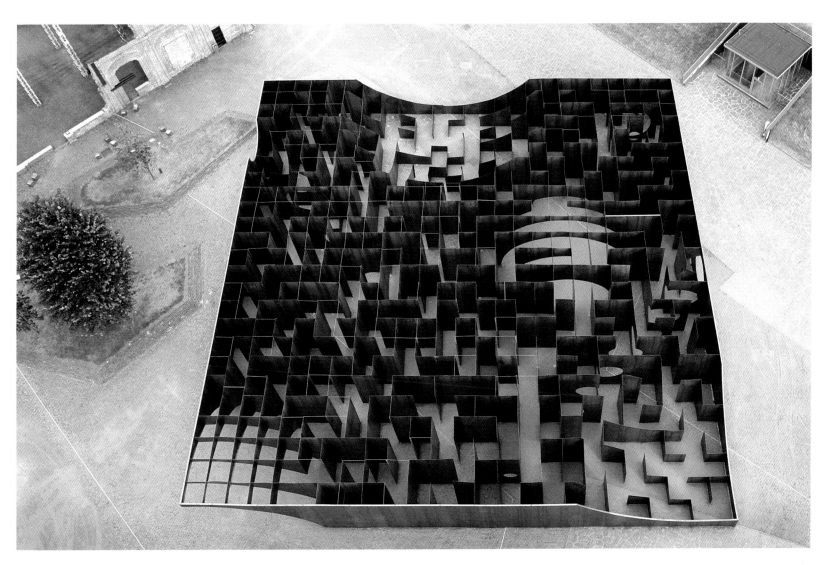

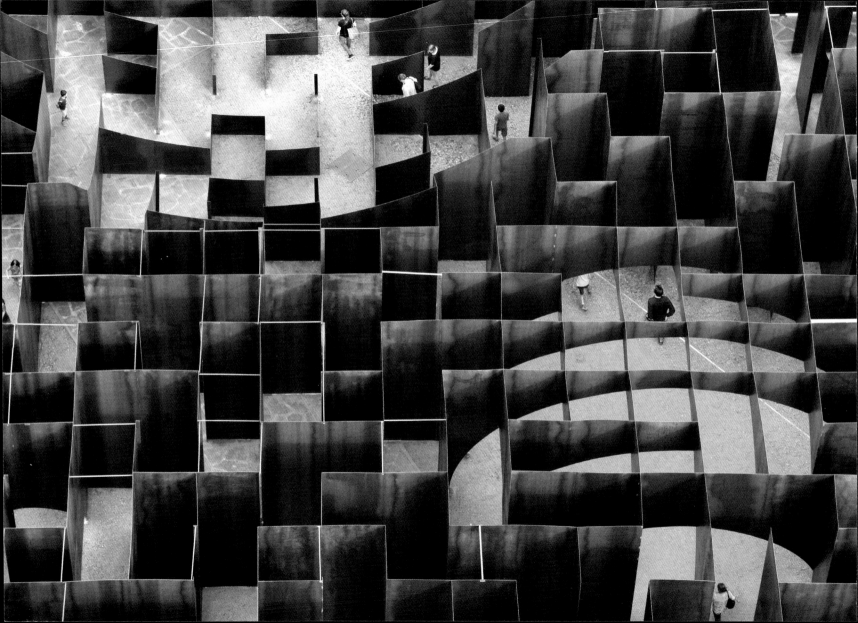

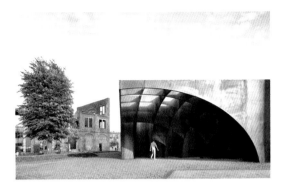

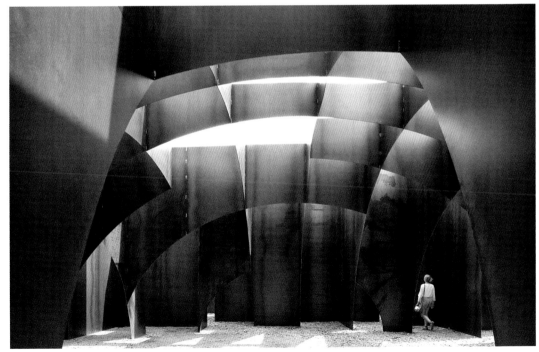

The maze intersects with spheres in four different spots, creating two covered spaces and two open plazas as places for play. As the designers explain, "This series of Boolean transformations creates spaces and perspectives that reinterpret the traditional labyrinth and transform it into a sculpture, an installation that inspires diverse perceptions. That way the path is transformed into a series of spatial and sculptural experiences. At the same time, the removal of volume works as 'framing.' It allows visitors to view the different parts of the labyrinth, intuit its progress, imagine the structure as a whole, and see it from different angles. These 'cuts' make the paths less mysterious and increase the methods for experiencing and moving through the space."

The various shapes that are cut into the steel panels result in multiple points of view and vary the maze's height, width, and design. Though visitors are moving through it following one main path, occasionally they come upon "windows" to the adjacent part of the path or entire sections of the maze. These help people orient themselves both within the grid and in relation to the outside world. In addition to the interior windows, there are also multiple cutouts that frame views of the surrounding countryside.

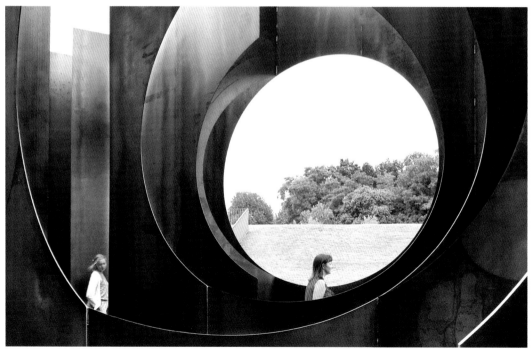

While most mazes leave visitors disoriented as they struggle to find their way to the center, this labyrinth feels more like a succession of different rooms in a large—albeit unusual—work of architecture.

The Boolean transformations applied crosswise work just like those applied from overhead: they open new perspectives and new opportunities to move through the space. As a result, traveling through the labyrinth is an atypically dynamic and active experience.

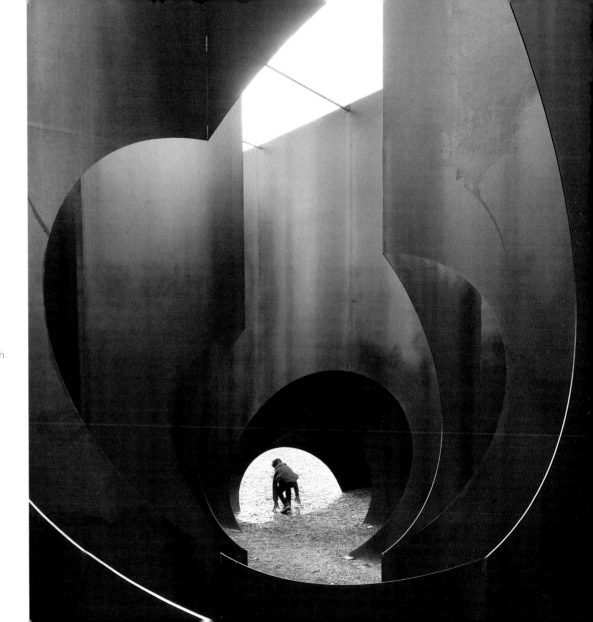

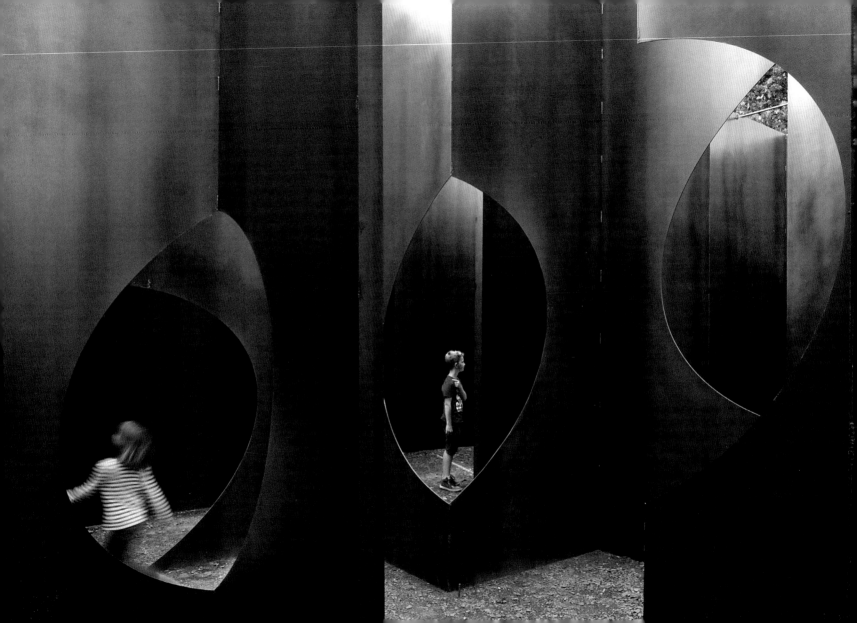

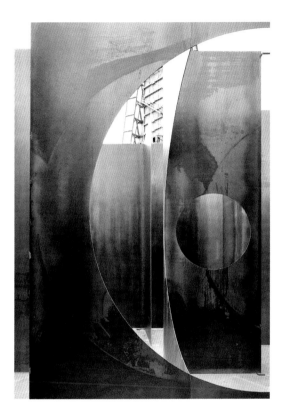
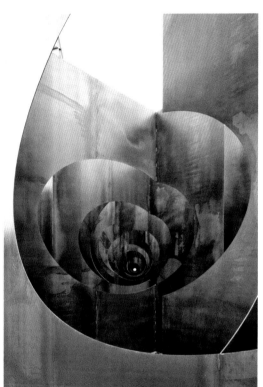
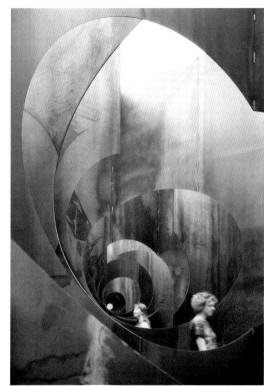

Labyrinth

- **Designer:** Jannis Kounellis
- **Location:** Fondazione Arnaldo Pomodoro, Milan, Italy, 2006
- **Size:** 6.5 x 5.9 feet (2 x 1.8 meters)
- **Material:** iron panels and coal

Labyrinth, by Italian-Greek artist Jannis Kounellis, a pioneer of the Italian Arte Povera movement of the late 1960s, was created for a solo exhibition of his work at the Fondazione Arnaldo Pomodoro in Milan. (The exhibition later traveled to Berlin [see page 176], Paris, and London.) Kounellis's art has long been concerned with the relationship between memory and tradition. Other favorite themes include mythological figures and symbols of classical culture, including the labyrinth.

In Milan the artist used the labyrinth as a narrative device throughout the exhibition; his *Labyrinth*, made of iron panels and coal, formed its own small universe within the large exhibition hall—a former industrial space belonging to the company Riva & Calzoni. Kounellis cleverly displayed a number of smaller artworks along the labyrinth's pathways. He thus highlighted these pieces, determined the order in which they were encountered, and contrasted the various materials used.

Labyrinth also served as the paradigm of a journey—another subject that Kounellis has studied from many different angles since the start of his career. Like all labyrinths and mazes, it was both located in its surroundings and separate from it, and encouraged visitors to examine the reasons behind their own path in life as they sought to reach its center.

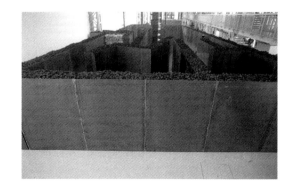

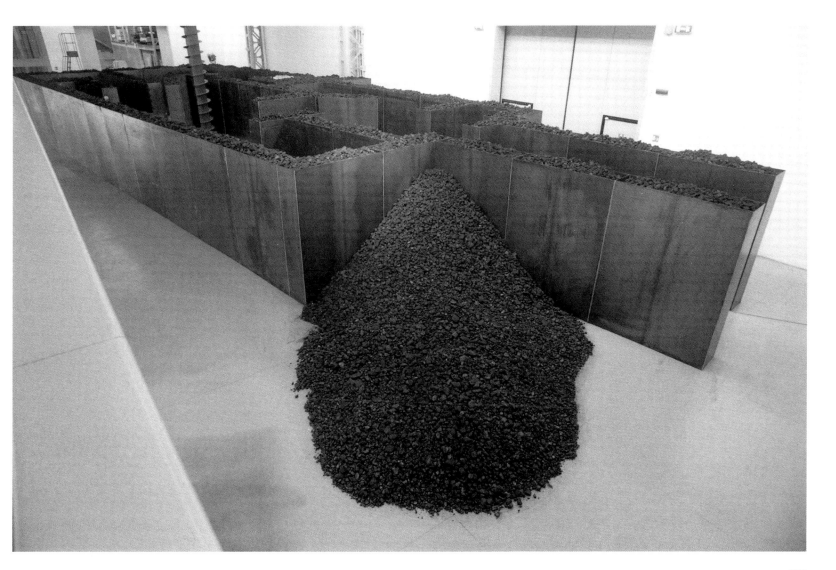

Labyrinth

- **Designer:** Jannis Kounellis
- **Location:** Neue Nationalgalerie, Berlin, Germany, 2007–8
- **Material:** steel

The labyrinth Kounellis created in Berlin was even more massive than the one installed at the Fondazione Arnaldo Pomodoro. In Berlin the solo exhibition was held at the renowned Neue Nationalgalerie building designed by Mies van der Rohe. The labyrinth restricted the light open space of the museum. Its tall steel walls, the curves of its path, and its various crossroads placed the public in unusually close contact with the artist's work and created distance from the rest of the museum. The labyrinth's hard, dark walls contrasted with the building's glass facade, and the installation functioned as a kind of guide for visitors, controlling their movement even as it disoriented them.

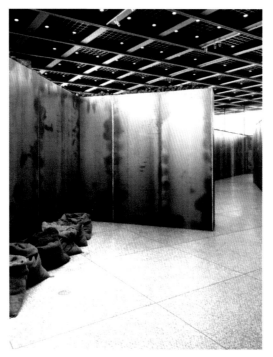
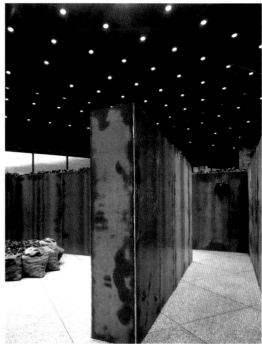

Kounellis generated what might be called "spatial confusion" to reflect various moments in his career and the different ways he approached them. His labyrinth had no true center, which made it even more disorienting. In dialoguing with the surrounding space, it radically changed perception of the architecture, indicating that the space was not completely tamed—Ariadne's thread is easily lost. Kounellis's *Labyrinth* reflected the past, as any retrospective must, but it also looked to the future, which is always uncertain. We must all adjust to meet it.

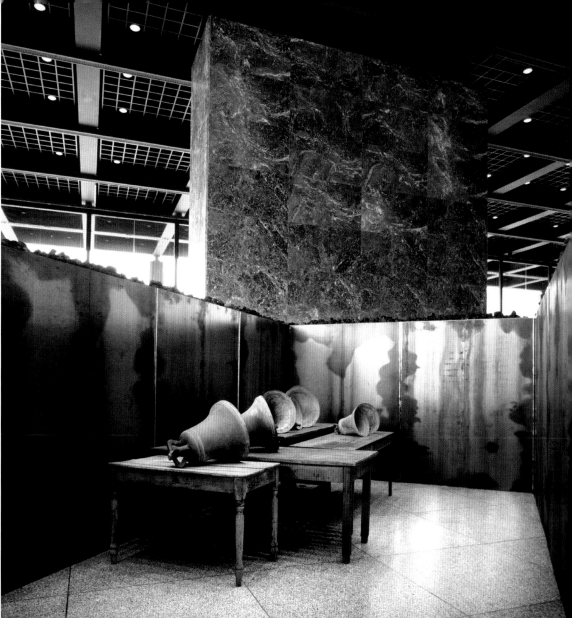

Meeting Slides

- **Designers:** Carsten Höller, Billie Tsien, and Tod Williams
- **Location:** Snow Show, Kemi, Finland, 2004
- **Size:** 10 x 100 x 100 feet (3 x 30 x 30 meters)
- **Material:** compacted snow

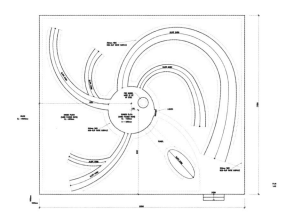

Stockholm artist Carsten Höller worked together with architects Billie Tsien and Tod Williams to create this snow sculpture for the 2004 Snow Show in Kemi, Finland, a small town near the Arctic Circle. The team's goal was to make a work of art that would go beyond mere observation—a sculpture that could be experienced directly by the public. At first glance, *Meeting Slides* is just a carved snow platform, but the sculpture actually comprises a number of labyrinthine ramps that visitors can slide down to a central space. To build these hidden slides, Höller, Tsien, and Williams first compacted snow into a single block, a large platform, that could then be sculpted. In other words, they made the actual piece by carving away and removing material, not by building it up out of snow and ice.

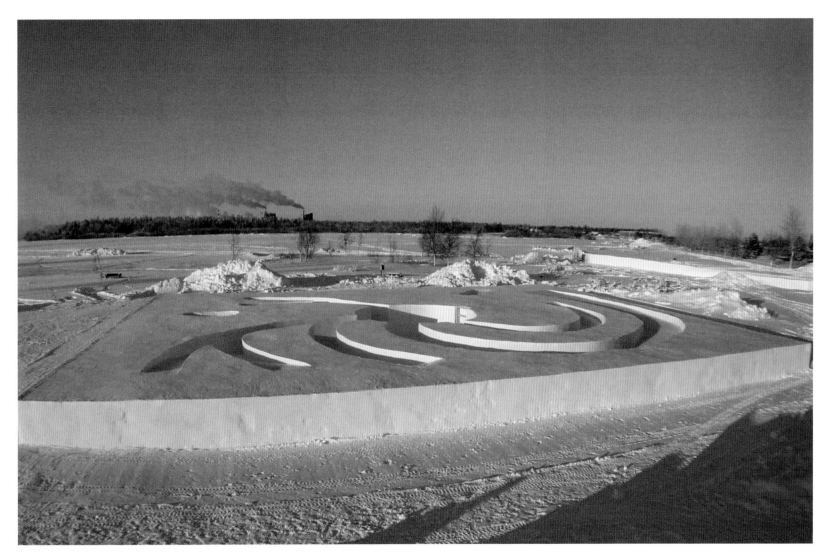

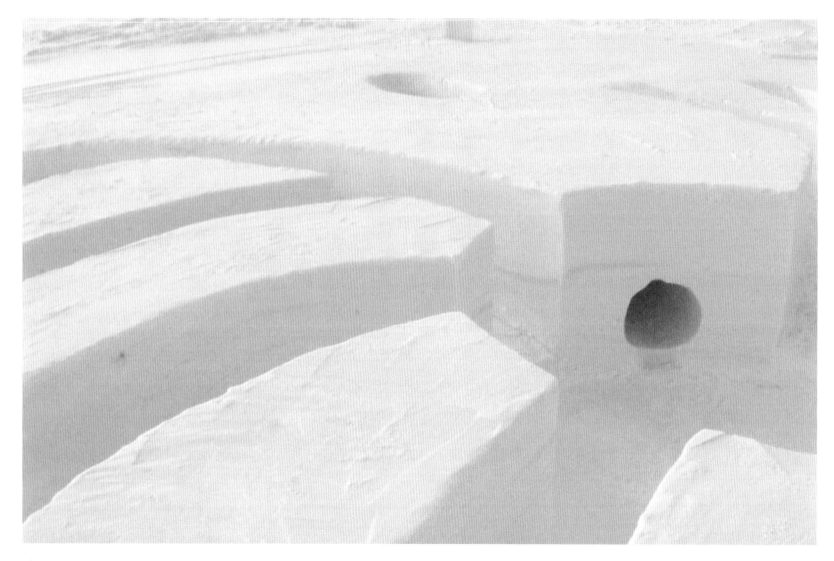

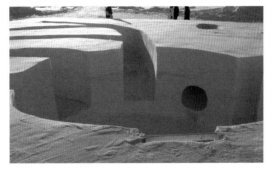

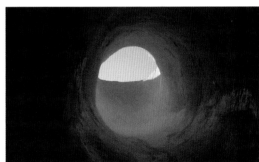

The first space the team cut into the platform was the circular chamber at the center, which is about 10 feet (3 meters) deep. Then a series of curved downhill slopes were created leading to it. Approached from the outside, the installation looked like a simple snow platform, but as visitors climbed to the top, they discovered that what seemed like a flat surface was in fact a dimensional space. The changing viewpoints visitors encountered when interacting with the installation were crucial to experiencing it. Visitors descended into the central chamber via slides. Once there, they could peek through a hole drilled into the snow to glimpse the world above. This created an element of surprise similar to the emotions evoked by a traditional labyrinth with its twists and turns and dead-end routes.

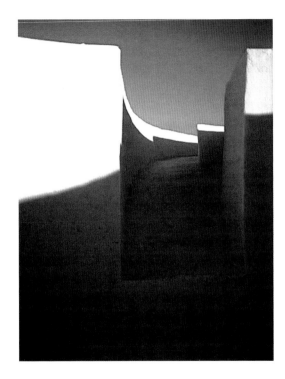
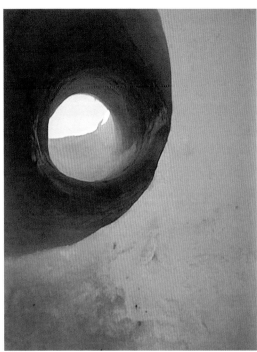

The ramps that wrapped around the central space can be compared to the paths that wind through a circular labyrinth. Their progress was simple, and their wide curves allowed visitors to see where they were going. Disorientation in this labyrinth was created through the change in vertical position.

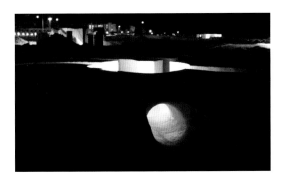
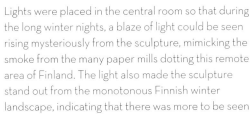
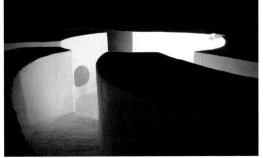
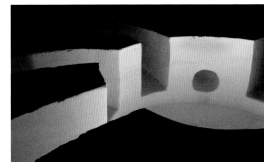

Lights were placed in the central room so that during the long winter nights, a blaze of light could be seen rising mysteriously from the sculpture, mimicking the smoke from the many paper mills dotting this remote area of Finland. The light also made the sculpture stand out from the monotonous Finnish winter landscape, indicating that there was more to be seen here than just an infinite field of snow—a specific site begging for exploration. In addition the light helped visitors orient themselves and lent some safety to the proceedings, as it would have been dangerous for people to enter the installation without being able to see its various levels.

Penal Colony 1

- **Designers:** Arata Isozaki and Yoko Ono
- **Location:** Snow Show, Rovaniemi, Finland, 2004
- **Size:** 40 x 40 x 40 feet (12 x 12 x 12 meters)
- **Material:** ice blocks

Japanese architect Arata Isozaki and artist Yoko Ono partnered to create this ice maze for the 2004 Snow Show in Finland. For their installation, one thousand blocks of ice were cut from a frozen lake. The blocks came from two different levels of depth, resulting in different properties: the blocks from a deeper level of the lake were generally better for construction and lighter in color, while those from a level closer to the surface were opaque due to having suffered the effects of atmospheric agents all winter long. Work on the installation frequently had to be halted because the temperature had fallen below -4 degrees Fahrenheit (-20 Celsius), making it impossible to cut the ice.

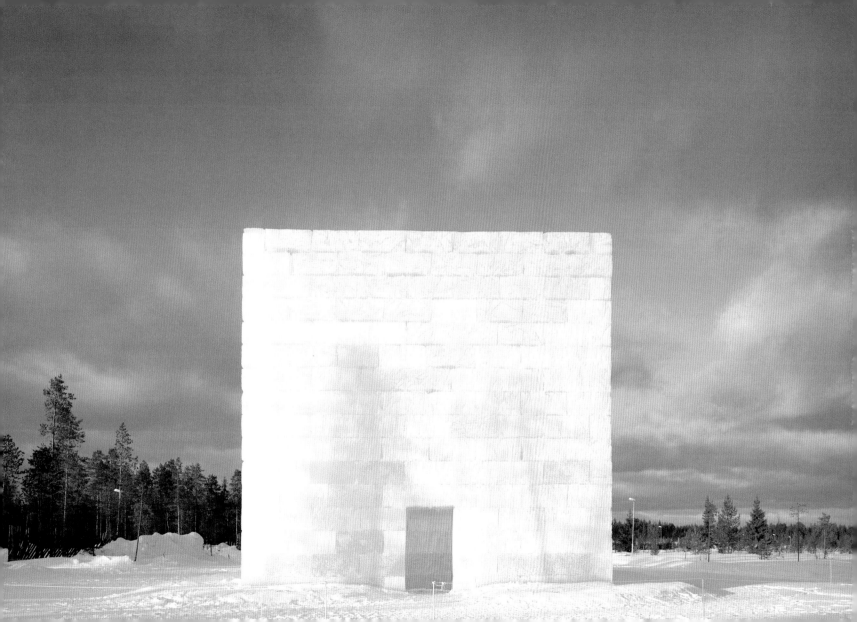

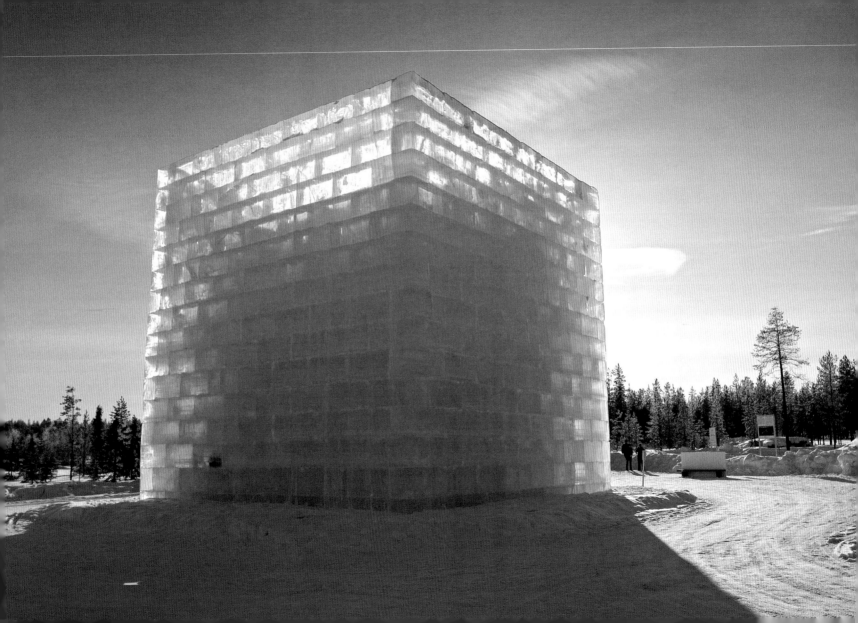

Penal Colony 1 had a square layout, with an entrance on the front and an exit on the opposite side. The multiple blocks of ice used to build its walls gave it a less oppressive tone than if it had been constructed of a single enormous chunk of ice.

Within the maze, the walls lining the path gradually got shorter toward the center, so that the space grew more visible and could be seen as a whole. Although the ice walls were more or less transparent, visitors walking the maze were confronted with several layers of it, as they made their way through the structure, so the space they experienced got increasingly opaque, and light penetrated the interior less and less. Coldness and darkness were the work's key emotional elements.

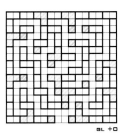
GL +0

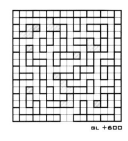
GL +600

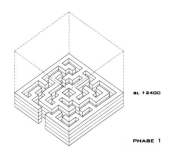
GL +2400

PHASE 1

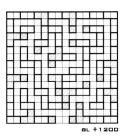
GL +1200

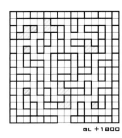
GL +1800

GL +9600
GL +7200
GL +4800
GL +2400
GL +0

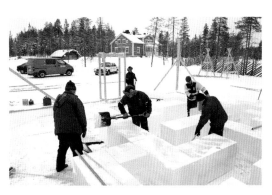

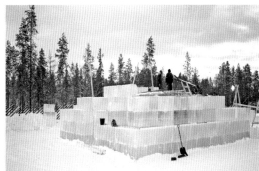

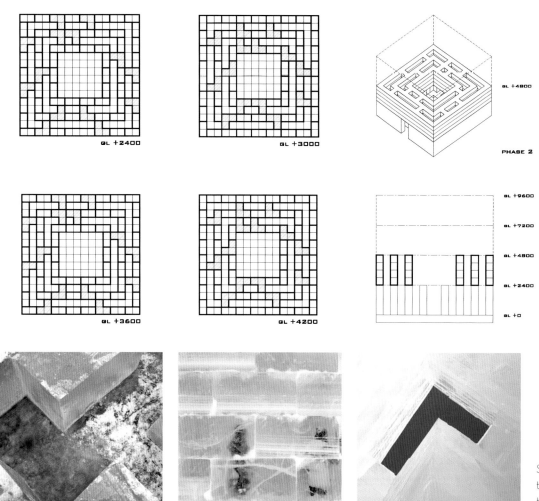

GL +2400

GL +3000

GL +4800

PHASE 2

GL +3600

GL +4200

GL +9600

GL +7200

GL +4800

GL +2400

GL +0

Standard-sized ice "bricks" were used to build the maze. Leaving out selected bricks in the layout created openings taking the form of passageways and skylights.

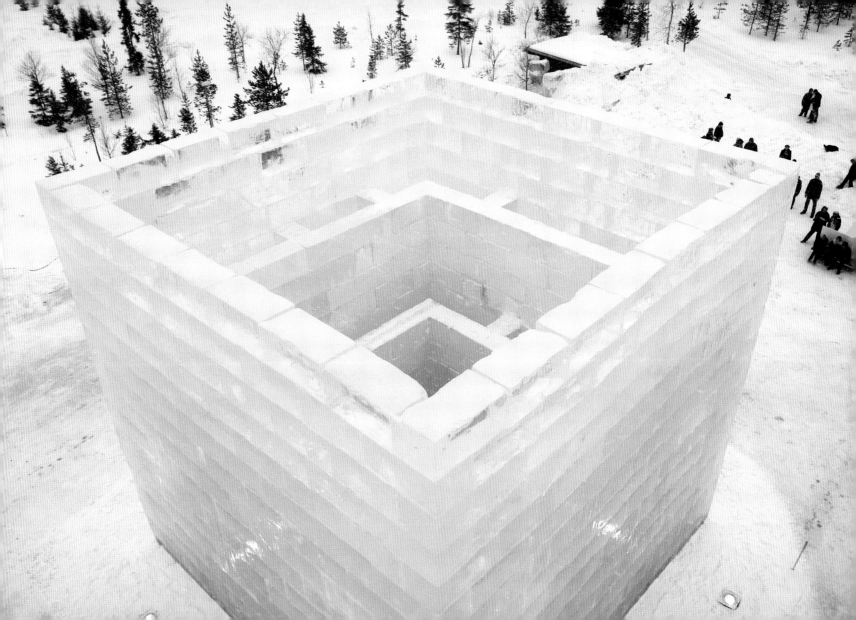

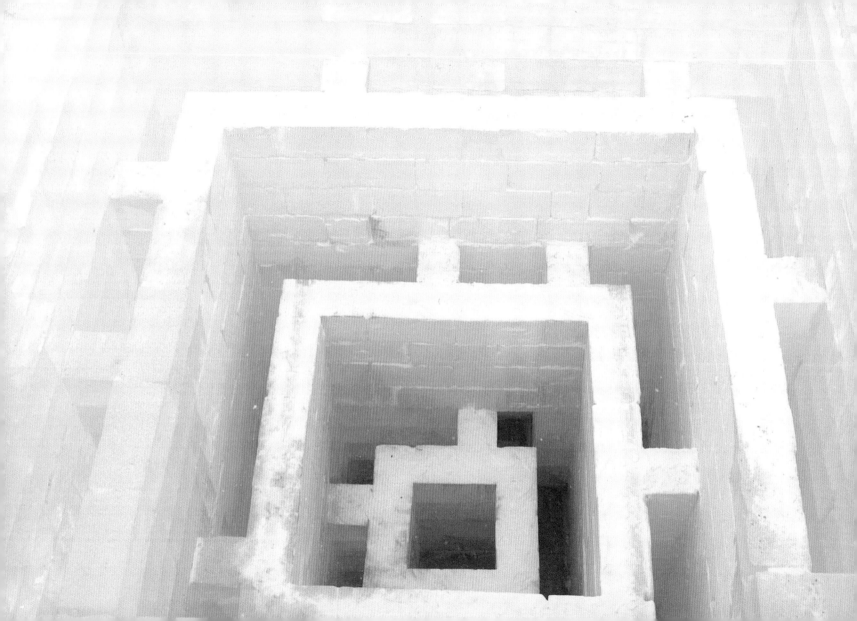

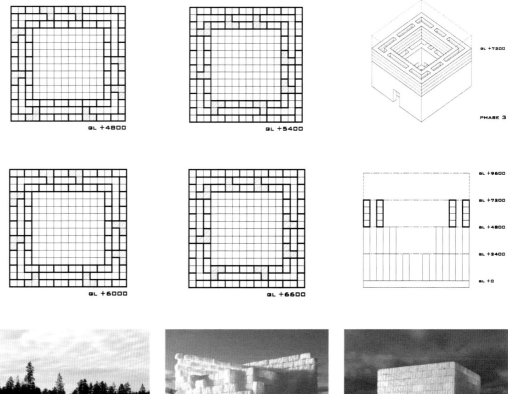

Like all of the work created for the Snow Show, *Penal Colony 1* fit perfectly into the environment. It was built with materials found on site and at the end of its lifespan returned to the landscape by melting in spring.

GL +7200

GL +7800

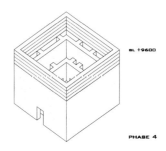

GL +9600

PHASE 4

GL +8400

GL +9000

GL +9600
GL +7200
GL +4800
GL +2400
GL +0

The model for the installation shows its concentric walls of decreasing heights. Working in a modular fashion with blocks of ice all the same size meant that it was relatively simple to create gaps by leaving out selected blocks. Like a classic Renaissance maze, *Penal Colony I* had passageways that led to the center and others that proved to be dead ends.

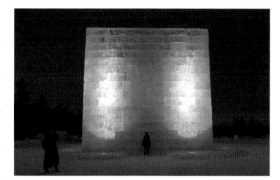

Seen from the outside lit up at night, *Penal Colony 1* resembled a fortress. The blocks of ice lent it a sense of both purity and heft as it loomed over the landscape, drawing visitors into the mysterious structure to begin their journeys toward the center.

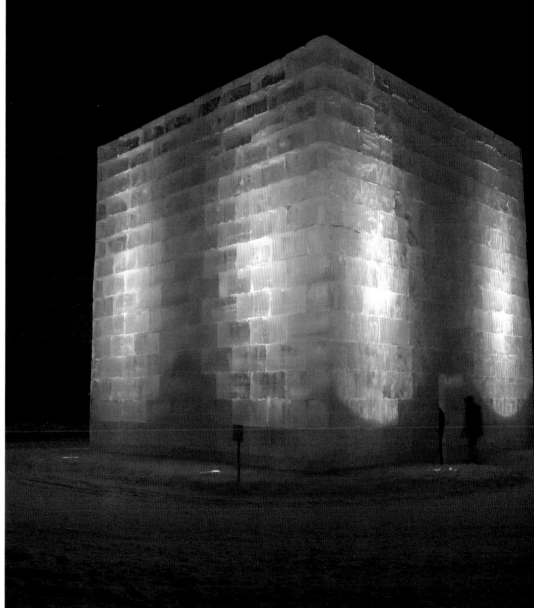

Penal Colony 2

- **Designers:** Arata Isozaki and Yoko Ono
- **Location:** Snow Show, Sestriere, province of Turin, Italy, 2006
- **Material:** snow

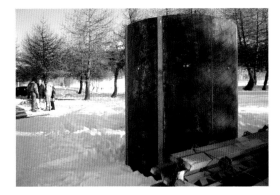

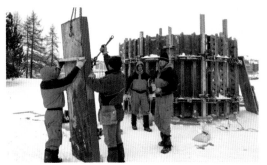

Penal Colony 2 was created for the 2006 Snow Show, which took place in northern Italy. Lance M. Fung, the curator of the show, asked participating artists and architects to work in close contact with the surrounding environment. One key directive was to use materials found on site, meaning snow and ice. Isozaki and Ono, who had already collaborated for the 2004 edition of the show in Finland, used molds to compact snow in order to form the circular walls of their labyrinth. They first built a wooden structure in the form of the labyrinth's design. Cranes then collected snow from the project site and deposited it directly into these wooden molds. There it compacted to form a solid architectural material. When the wooden walls were removed, a clean, homogenous, sturdy structure was revealed.

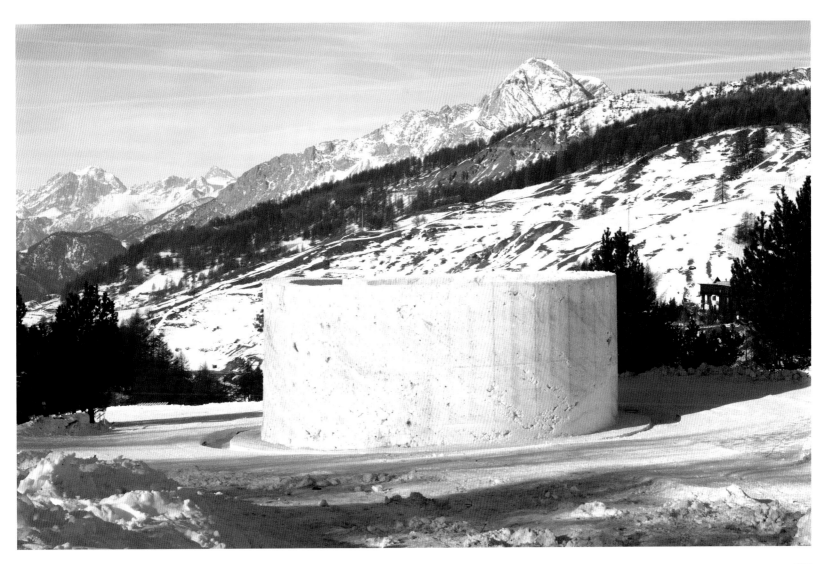

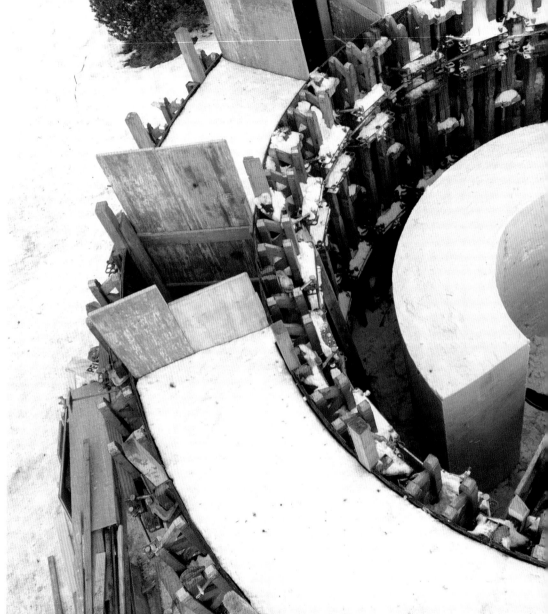

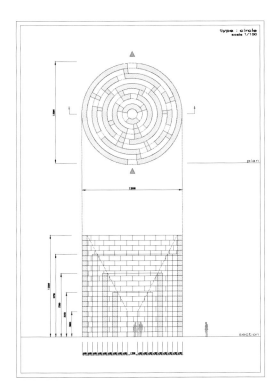

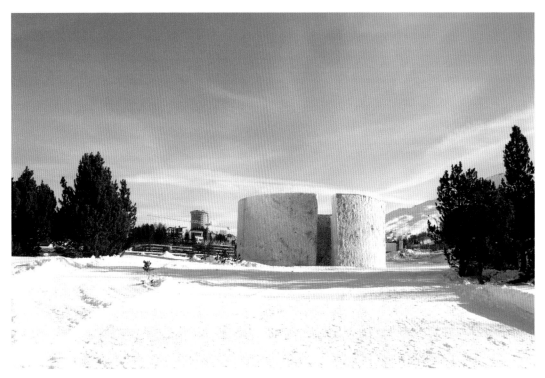

Penal Colony 2 was a classic unicursal labyrinth with just one route that led from the exterior to a central room. The walls were concentric circles that decreased in height toward the center. The solid snow walls and the closed exterior gave the work a prison-like quality.

Isozaki and Ono allowed their labyrinth to follow natural processes. The snow walls melted with the passage of time, until the site once again blended seamlessly back into the environment. Returning visitors to the show could witness the progression of the various phases, as the labyrinth collapsed and then, ultimately, disappeared from view.

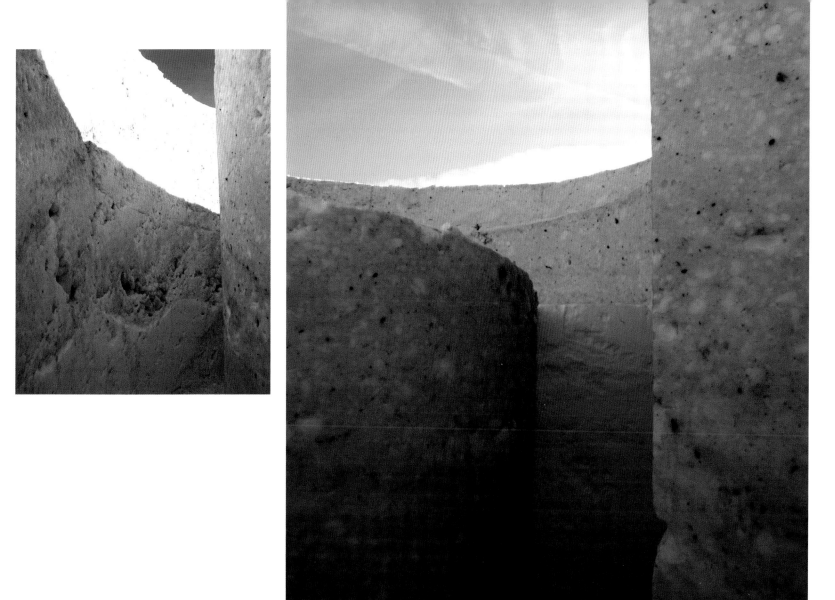

Salt Labyrinths

- **Title:** Labyrinth
- **Designer:** Motoi Yamamoto
- **Location:** Halsey Institute of Contemporary Art, Charleston, South Carolina, USA, 2006
- **Size:** 23.6 x 23.6 feet (7.2 x 7.2 meters)
- **Material:** sea salt

Japanese artist Motoi Yamamoto creates fantastic labyrinths and mazes made of sea salt. Each one begins with a sketch that is further refined using a computer. Then Yamamoto pours the intricate composition with sea salt on the floor of the exhibition space, working alone in this slow process, like a monk tending a Zen garden in the Japanese tradition. Typically, more than one vantage point is provided for viewers of the work: they can study it from the level on which it was created, usually the floor of a museum or art gallery, or they can view it from above in its entirety, from a higher level. At the end of the exhibition, Yamamoto invites the public to help him destroy the labyrinth; together they collect the salt and toss it back into the sea in a kind of collective ritual of respect for the cycle of life.

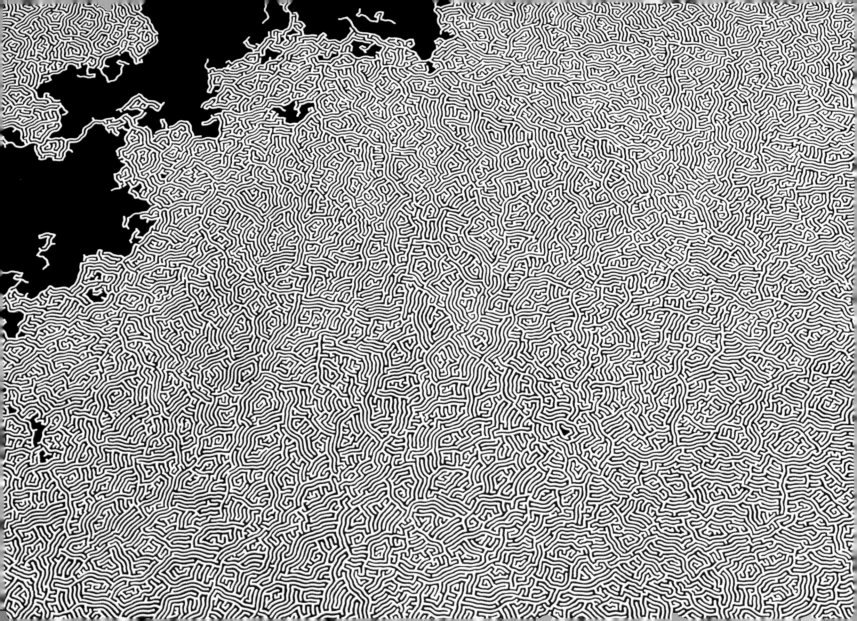

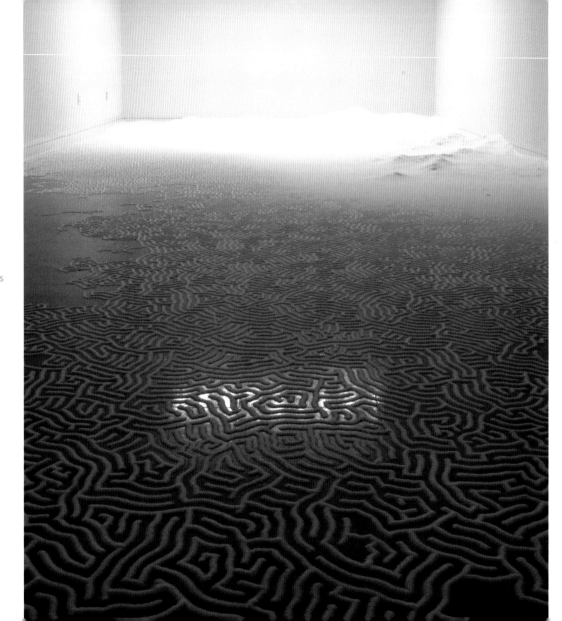

- **Title:** Labyrinth
- **Designer:** Motoi Yamamoto
- **Location:** Van Every/Smith Gallery, Davidson College, Davidson, North Carolina, USA, 2006
- **Size:** 10.5 x 36 feet (3.2 x 11 meters)
- **Material:** sea salt

If primitive pagan labyrinths were traveled to perform a ritual, such as a prayer to the gods, Yamamoto's salt labyrinths can similarly be seen as a kind of prayer and balm for the soul. The artist began to create his saltscapes after his sister died of brain cancer. The twisting and winding paths of his installations in fact resemble the human brain, as if its folds and loops were unfolded here. The choice of material is also significant—in Japan salt is used for funeral rites, but is also considered a necessary element of life.

- **Title:** Labyrinth
- **Designer:** Motoi Yamamoto
- **Location:** Ierimonti Gallery, Milan, Italy, 2005
- **Size:** 18 x 36 feet (5.5 x 11 meters)
- **Material:** sea salt

Designing the intricate twists and turns of his salt installations is a healing process for Yamamoto. His labyrinths cannot be traveled physically; they are intimate pathways that reflect the growth and evolution of an internal universe, a personal maturation. Indeed, the first of these works offered a single route from the exterior to the center and clearly captured a deep and previously unexpressed pain stemming from the artist's inability to bring his sister back to life. Later Yamamoto began to make labyrinths with multiple paths and often with multiple entrances and exits. Those works symbolized the processing of grief and hope, and the relationship between the good and the bad that marks all human existence.

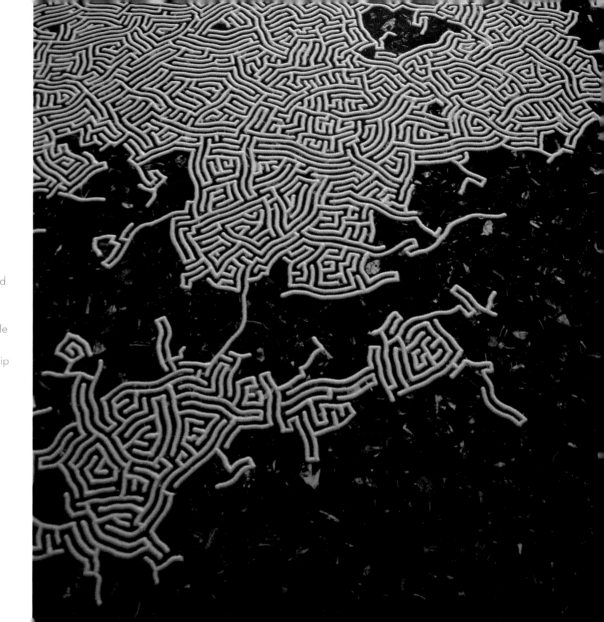

Index of Labyrinths

Bibliography

Adams, Henry. *Mont Saint Michel and Chartres.* Bournemouth and London: Constable and Company, 1950.

Argan, Giulio Carlo. *L'arte moderna* [Modern art]. Florence: Sansoni, 1988.

Attali, Jacques. *Chemin de sagesse: traité du labyrinthe.* Paris: Fayard, 1996. Translated by Joseph Rowe under the title *Labyrinth in Culture and Society: Pathways to Wisdom.* Berkeley: North Atlantic Books, 1999.

Augé, Marc. *Non Luoghi.* Milan: Eleuthera, 1997. Translated by John Howe under the title *Non-Places: Introduction to an Anthropology of Supermodernity.* London and New York: Verso, 1995.

Azzi Visentini, Margherita. *Il giardino veneto. Storia e conservazione* [The Veneto garden. History and conservation]. Milan: Electa, 1988.

Biedermann, Hans. *Enciclopedia dei simboli.* Milan: Garzanti, 1991. Translated by James Hulbert under the title *Dictionary of Symbolism: Cultural Icons and the Meanings Behind Them.* New York: Penguin, 1994.

Bonito Oliva, Achille. *Luoghi del silenzio imparziale. Il labirinto contemporaneo* [Sites of impartial silence. The modern labyrinth]. Milan: Feltrinelli, 1981.

Bord, Janet. *Mazes and Labyrinths in the World.* London: Latimer New Dimensions, 1976.

Borges, Jorge Luis. *Finzioni* [Fictions]. Turin: Einaudi, 1988.

Borges, Jorge Luis. *L'Aleph* [The Aleph]. Milan: Feltrinelli, 1986.

Calvino, Italo. *Le città invisibili.* Turin: Einaudi, 1972. Translated by William Weaver under the title *Invisible Cities.* New York: Harcourt Brace, 1972.

Campioni, Gabriella. *Il labirinto—segreto percorso di luce* [The labyrinth—secret path of light]. Milan: Centro Studi & Ricerche Cosmòs, 1994.

Chapuis, Frédy. *Le test du labyrinthe* [The labyrinth test]. Bern and Stuttgart: Verlag Hans Huber, 1959.

Chevalier, Alain, and Alain Gheerbrant. *Dizionario dei simboli*. Milan: Rizzoli, 1986. Translated by John Buchanan-Brown under the title *The Penguin Dictionary of Symbols*. London: Penguin, 1996.

Conti, Lino, ed. *Labyrinthos: materiali per una teoria della forma* [Labyrinths: material for a theory of form]. Florence: Alinea, 1994.

Conty, Patrick. *La géometrie du labyrinthe*. Paris: Albin Michel, 1996.

Deleuze, Gilles, and Félix Guattari. *Rizoma*. Parma: Pratiche Editrice, 1976. Translated by Brian Massumi under the title *A Thousand Plateaus: Capitalism and Schizophrenia*. Minneapolis: University of Minnesota Press, 1987.

Fanelli, Maria Cristina. *Labirinti. Storia, geografia e interpretazione di un simbolo millenario* [Labyrinths. History, geography, and interpretation of an age-old symbol]. Rimini: Edizioni Il Cerchio, 1997.

Field, Robert. *Mazes: Ancient & Modern*. St. Albans: Tarquin Publications, 1999.

Fisher, Adrian, and Diana Kingam. *Mazes*. Buckinghamshire: Shire Publications, 1991.

Hohmuth, Jürgen. *Labyrinths & Mazes*. Munich: Prestel, 2003.

Impelluso, Lucia. *Giardini, orti e labirinti* [Gardens, kitchen gardens and labyrinths]. Milan: Mondadori Electa, 2005.

Kerényi, Kàroly. *Nel labirinto* [In the labyrinth]. Turin: Bollati Boringhieri, 1983.

Kern, Hermann. *Labirinti. Forme e interpretazioni, 5000 anni di presenza di un archetipo*. Milan: Feltrinelli, 1981. Translated under the title *Through the Labyrinth: Designs and Meanings over 5,000 Years*. Munich: Prestel, 2005.

Lepore, Francesca R. *Dentro e fuori il labirinto. La grande saga del labirinto fra pietre, arte e giardini* [In and out of the labyrinth. The story of the labyrinth in stones, art, and gardens]. Rimini: Idea Libri, 2002.

Lonegren, Sig. *Labyrinths: Ancient Myths and Modern Uses*. New York: Sterling, 2008.

Orvieto, Paolo. *Labirinti castelli giardini. Luoghi letterari di orrore e smarrimento* [Labyrinths castles gardens. Literary places of horror and confusion]. Rome: Salerno Editrice, 2004.

Pennick, Nigel. *Mazes and Labyrinths*. London: Robert Hale, 1994.

Reed Doob, Penelope. *The Idea of the Labyrinth from Classical Antiquity through the Middle Ages*. Ithaca: Cornell University Press, 1990.

Reviglio della Veneria, Maria Luisa. *Il labirinto: la paura del Minotauro e il piacere del giardino* [The labyrinth: fear of the Minotaur and the pleasure of the garden]. Florence: Polistampa, 1998.

Saint-Hilaire, Paul de. *L'universe Secret du Labyrinthe*. Paris: Robert Laffont, 1992.

Sambo, Marco M. *Labirinti. Da Cnosso ai videogames* [Labyrinths: from Knossos to videogames]. Rome: Castelvecchi, 2004.

Santarcangeli, Paolo. *Il libro dei labirinti* [The book of labyrinths]. Milan: Frassinelli, 2005.

Saward, Jeff. *Labyrinths & Mazes—The Definitive Guide*. London: Gaia Books, 2003.

Saward, Jeff. *Magical Paths: Labyrinths & Mazes in the 21st Century*. London: Miller Mitchell Beazley, 2002.

Sedlmayr, Hans. *Perdita del centro*. Milan: Borla Edizioni, 1948. Translated by Brian Battershaw under the title *Art in Crisis: The Lost Centre*. London: Hollis & Carter, 1957.

Shepherd, Walter. *Big Book of Mazes & Labyrinths*. New York: Dover Publications, 1973.

Vincenzi, Sergio, ed. *Il labirinto* [The labyrinth]. Bologna: Grafis, 1985.

Artist Biographies

Michael Ayrton

English writer and artist Michael Ayrton (1921–1975) was a well-known painter, sculptor, designer, critic, and novelist. His enormous body of work includes sculptures, illustrations, poetry, and fiction that together express his deep and abiding interest in the themes of flight, mythology, mirrors, and mazes.

Giovan Battista Bianchi

Giovan Battista Bianchi (1631–1687) was an Italian architect and sculptor. His best-known work is the Villa Arvedi in Grezzana, located in the province of Verona.

Michel Benoist

Michel Benoist (1715–1774) was a French architect hired by Giuseppe Castiglione, a fellow Jesuit artist and missionary, who was working for Emperor Qianlong. Together they designed and built the pavilions that would become a favorite spot for the emperor and his concubines to while away the afternoons.

BIG | Bjarke Ingels Group

BIG is an architecture firm founded by Bjarke Ingels in 2005. It has offices in Copenhagen and New York and works within the fields of architecture, urbanism, research, and development.
www.big.dk

Pier Carlo Bontempi

Italian architect Pier Carlo Bontempi (born in 1954) is a member of the scientific committee of INTBAU (International Network for Traditional Building, Architecture, and Urbanism), which works under the patronage of Prince Charles the Prince of Wales to promote design on a human scale.
www.piercarlobontempi.it

Greg Bright

Greg Bright (born in 1951) is an Englishman well known as a skillful maze designer and an author of maze books. In 1971 he acquired a field near Glastonbury, England, and spent a year digging a complex maze into it. In 1975 he laid out a hedge maze at Longleat for Lord Wymouth.

Jim Buchanan

With his labyrinth and maze installations, Scottish artist Jim Buchanan (born in 1965) intends to create a dialogue between the materials, nature, and visitors. www.landartist.co.uk

Giuseppe Castiglione

Giuseppe Castiglione (1688–1766) is the most famous Italian artist of his era to have worked in China. Emperor Qianlong engaged him to design and build the fountains and decorations for the Western-style pavilions in the gardens of the Summer Palace in the Forbidden City.

Randoll Coate

Randoll Coate (1909–2005) was a British diplomat with a passion for the maze and its evolution over time. He designed and built more than fifty mazes in Great Britain and around the world, all of them packed with hidden symbols.

Nick Coombe

Nick Coombe (born in 1958) is a London architect whose work examines the relationship between architecture and art. www.coombearchitecture.com

Lucien den Arend

Dutch artist Lucien den Arend (born in 1943) is a sculptor who creates both land art and public art. Rather than creating pieces that are inserted into a natural environment, he transforms the environment itself into a work of art. www.denarend.com

Chris Drury

British environmental artist Chris Drury (born in 1976) creates site-specific land art installations. His work explores the connections between different phenomena and aspects of life, specifically examining nature and culture and microcosm and macrocosm. www.chrisdrury.co.uk

Davide Dutto

Davide Dutto (born in 1971) is an Italian architect based in Turin. He started his office in 2000, working on projects of interior design and retail. In the same year, he met Franco Maria Ricci, who asked him to contribute to the design of the Masone Labyrinth. www.davideduttoarchitetto.it

Richard Fleischner

American artist Richard Fleischner (born in 1944) has worked in environmental art since the 1970s. He sees natural elements as sculptural materials. Labyrinths and mazes are both recurring themes in his work and a source of inspiration for it.

Girolamo Frigimelica

Italian architect Girolamo Frigimelica (1653–1732) was a late humanist artist involved in architecture, science, and art. His best-known work is the Villa Pisani in Stra.

Gijs Van Vaerenbergh

Gijs Van Vaerenbergh is a Belgian firm at the intersection of art and architecture, founded by Pieterjan Gijs and Arnout Van Vaerenbergh, with an important focus on public space.
www.gijsvanvaerenbergh.com

Dan Graham

Dan Graham (born in 1942) is an American artist, writer, and curator. His most recent work includes installations, video, sculpture, and photography, and his pieces are often at the intersection of sculpture and architecture.

Jeppe Hein

Jeppe Hein (born in 1974) divides his time between Copenhagen and Berlin. He creates interactive installations that combine elements from the world of entertainment with the minimalist tradition and conceptual art.
www.jeppehein.net

Carsten Holler

Carsten Holler (born in 1961) is a Belgian artist whose work directly involves the public. One of his major interests is human behavior in response to a new spatial condition or an object that calls for interaction.

Robert Irwin

After beginning his career as a painter, American artist Robert Irwin (born in 1928) went on to create light installations that addressed space, which led to his work in landscape art and public space designs, including the Central Garden at the Getty Center in Los Angeles.

Arata Isozaki

A student of Kenzo Tange, Japanese architect Arata Isozaki (born in 1931) creates work that is influenced by various schools of thought and style. Instead of hewing to a single style, Isozaki considers architectural concepts in relation to their various political, social, and cultural contexts.
www.isozaki.co.jp

Shona Kitchen

Shona Kitchen (born in 1968) is a multidisciplinary British artist and designer. Her work explores the intersections between the physical and virtual and the ways in which they manifest themselves as new spatial experiences.
www.shonakitchen.com

Jannis Kounellis

Greek artist Jannis Kounellis (born in 1936) was a leader of the Arte Povera movement. In his twenties he moved to Rome to study, and exile would become a major theme in his work, where it is expressed with iron, coal, and burlap bags installed in an abandoned place, a shelter.

Jan Krtička

Czech artist Jan Krtička (born in 1979) focuses on installations that play with space—whether a natural environment or a gallery. The relationships between interior and exterior, open and closed spaces, and manmade and natural elements are central themes in his work.

Italo Lanfredini

Since the 1970s, Italian sculptor Italo Lanfredini (born in 1948) has designed work that dialogues with its location. His works are meant to be explored, experienced, and entered. He focuses on themes such as thresholds, labyrinths, and gardens. The relationship between manmade items and the landscape is also a major interest of his. www.italolanfredini.it

Lee Bul

Korean artist Lee Bul (born in 1964) works mainly with sculpture and installations. In her work, she broaches themes such as patriarchy and the marginalization of women through representation of ideologies that dominate the political spheres of various societies. www.leebul.com

George London

George London (ca. 1640-1740) was a well-known English nurseryman and garden designer in the seventeenth century who worked largely in the baroque style. He designed the renowned Brompton Park Nursery in 1681.

Robert Morris

American sculptor, visual artist, and writer Robert Morris (born in 1931) began his career as a painter, then became involved in the performing arts, including dance and choreography. In the 1970s, he returned to figurative arts and started to explore the theme of nuclear war. In the 1990s, he turned to installations that play off the relationship between the viewer's body and the surrounding space.

Olaf Nicolai

Olaf Nicolai (born in 1962) is a German artist whose work stands in the tradition of conceptual art. Using a variety of media, he questions our habitual ways of seeing things.

Yoko Ono

Yoko Ono (born in 1933) is an American performance artist, musician, and filmmaker, as well as a foremost peace activist originally from Japan. She has long been part of the New York art scene as part of Fluxus. Her work was the subject of a retrospective at the Whitney Museum of American Art in 1989. www.imaginepeace.com

Marta Pan

Marta Pan (1923-2008) was a French sculpturist originally from Hungary who worked with Constantin Brancusi and Le Corbusier and investigated the relationship between architecture and sculpture. Her work grew out of an interest in movement, which became a central element of her pieces. She often worked in public spaces.

Pezo Von Ellrichshausen

Mauricio Pezo and Sofia Ellrichshausen founded the Pezo Von Ellrichshausen studio in Chile in 2002. Their work was included in the fifth Ibero-American Biennial and the 2010 Venice Biennale. It was exhibited at the Royal Academy of Arts in 2014 and is part of the collection of the Museum of Modern Art in New York. www.pezo.cl

Franco Maria Ricci

In 1965 Franco Maria Ricci (born in 1937) founded the Italian publishing house FMR, which publishes high-end work, such as the *La Biblioteca di Babele* series edited by Jorge Luis Borges. Ricci has been working on his labyrinth in Fontanellato (province of Parma) since 2005. www.francomariaricci.com

John Schofield

John Schofield is a craftsman based in Traquiar, Scotland.

Tod Williams Billie Tsien Architects

Husband-and-wife team Tod Williams and Billie Tsien founded their own studio in New York in 1974. In addition to working as architects, they have a long history of teaching at various universities, including Harvard and Yale. Their work is often described as an elegant interpretation of neomodernism, and they have worked on many large-scale public projects with great attention to context, detail, and materials. In 2012 they participated in the thirteenth Venice Architecture Biennale with the theme of Common Ground. www.twbta.com

Henry Wise

English garden designer Henry Wise (1653-1738) was an apprentice to George London and worked on the gardens at Hampton Court, Chelsea Hospital, Longleat, and Chatsworth, often taking inspiration from gardens in France and the Netherlands.

Motoi Yamamoto

Motoi Yamamoto (born in 1966) is a Japanese artist who began working with installations made of salt after the death of his sister, both to heal his pain and to memorialize her. His earliest works depicted his sister, but from there he branched out to create mazes and floating gardens that can be seen as part of the development of his healing process. www.motoi.biz

Credits

Author's note:

With this book, I aim to show readers the different forms and shapes labyrinths and mazes have taken during the centuries. Some of the works featured in this volume have been destroyed, others have changed, and yet others are currently closed for maintenance. Should you wish to visit any of the existing labyrinths and mazes, please contact the respective institutions for more information.